Leonardo da Vinci's FLYING MACHINES

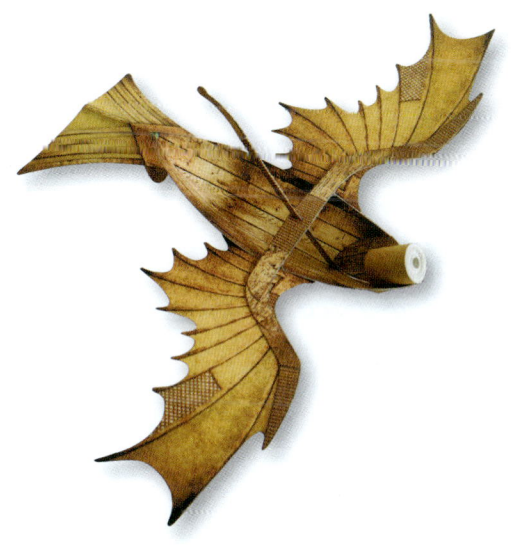

ANDREW DEWAR

TUTTLE Publishing

Tokyo | Rutland, Vermont | Singapore

CONTENTS

Introduction 4
Leonardo's Romance with Flight 6
Tools and Techniques 24
Test-flying Your Planes 28
Hand-launching Your Planes 32
Using the Slingshot Launcher 34

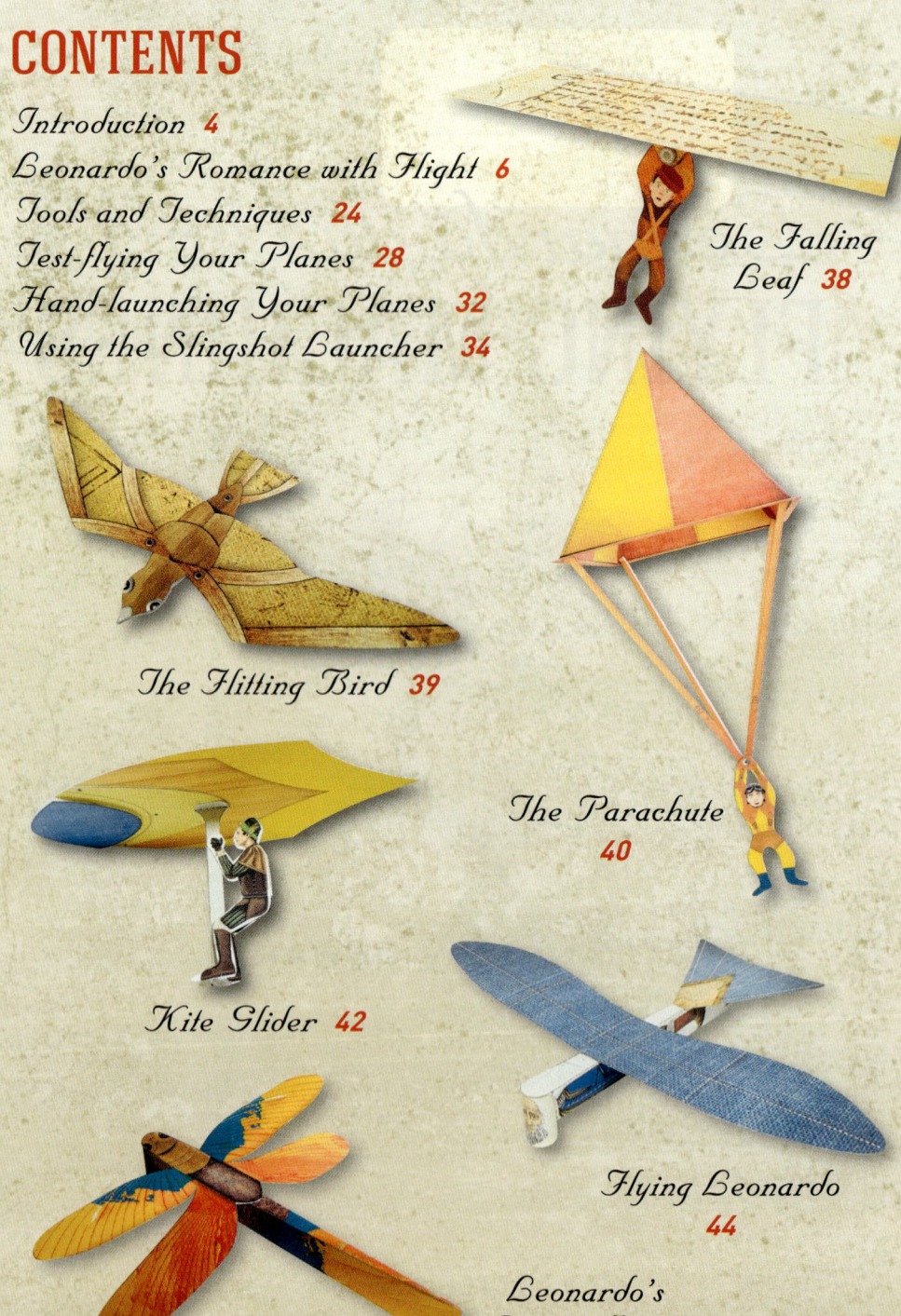

The Falling Leaf 38

The Hitting Bird 39

The Parachute 40

Kite Glider 42

Flying Leonardo 44

Leonardo's Dragonfly 46

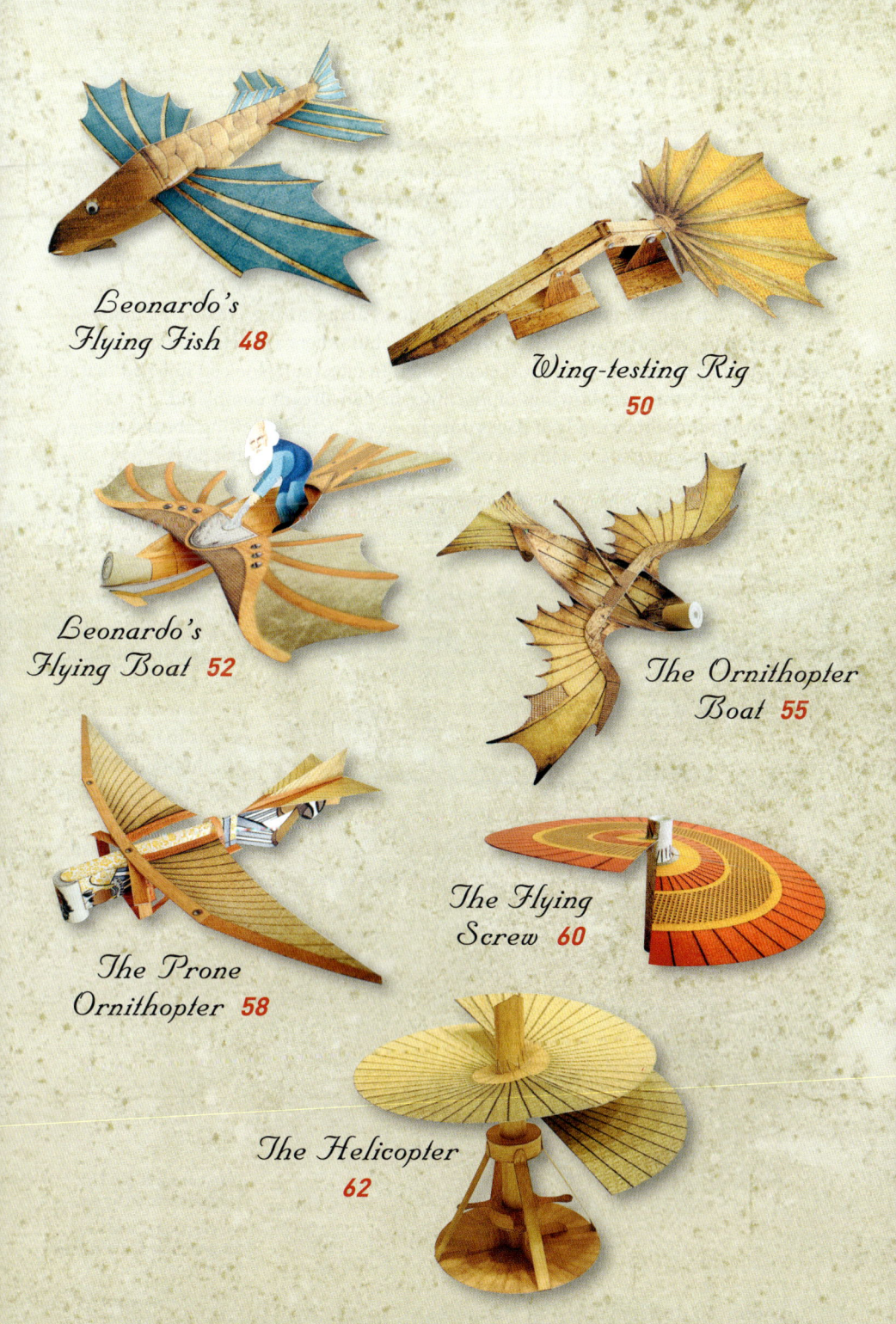

MAKING LEONARDO'S FLYING MACHINES

Just about every book on the history of airplanes has a sketch or two by Leonardo da Vinci. There might be the sketch of the helicopter, or the parachute, or one of the drawings of the ornithopters. More often than not, there are several sketches. But when you read the text, it almost always says, "But they did not fly."

Didn't they?

Are we sure?

Leonardo left behind thousands of pages of notes and drawings, including many sketches of flying machines. Some are just doodles, but others are detailed schematic diagrams that look almost ready for the carpenter. In fact, many look so finished that it is tempting to think they are drawings of machines he had already completed.

Nowhere in those thousands of pages does he report actually getting aboard one and flying. But, just because there is no record, that doesn't mean he didn't do it.

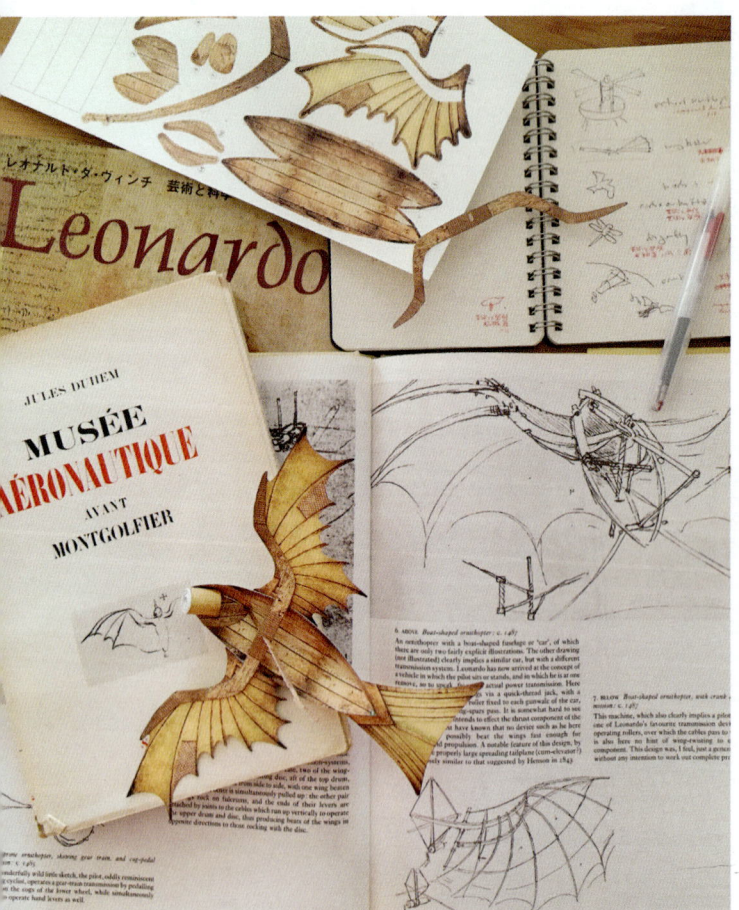

When I look at his drawings I can't help thinking that many of them were actually built and tested, if only as models. And as soon as that thought pops into my head, my "inner Leonardo" begins to wonder how I could build and fly them. And as soon as that happens, I reach for paper and scissors!

Left: Leonardo put his thoughts into pictures...

Facing page: ...and I've turned those pictures into flying models.

4 Leonardo da Vinci's Flying Machines

One great thing about paper airplanes is that you can quickly build a prototype of anything you can imagine, and test it without worrying about getting hurt if it crashes. So it was an easy step for me to go from looking at Leonardo's sketches to actually building and flying paper models. In fact, I've been building them for a long time. Some of the models in this kit date back almost two decades! But because I only had Leonardo's drawings to work with, I had to imagine what he was thinking when he drew them. How did they move? What were they made of? Where would they balance, and would the wings and tail be big enough? Soon, I began to understand the way Leonardo thought, and sometimes I almost felt I was becoming Leonardo.

The planes in this set are ready to assemble and enjoy. I can promise you that these models really do fly. The hard part—the pondering and examining and interpreting and testing—has been done already by Leonardo and I, so all you need to do is put them together and take them to the park! But I think you'll find, as you build and then fly these models, that you'll start to feel like you're becoming Leonardo too. You'll feel like a Leonardo who is watching his designs take to the air, an ecstatic Leonardo jumping up and down with excitement, a Leonardo who has, at last, learned how to fly!

Andrew Dewar

Making Leonardo's Flying Machines 5

LEONARDO'S ROMANCE WITH FLIGHT

Leonardo's Great Curiosity

Leonardo da Vinci was probably the most curious person in history. There are very few, if any, people who could have filled so many pages with the variety of drawings and notes that Leonardo did. His curiosity kept him very busy. He was a painter, a sculptor, an architect, a military engineer, a designer of weapons and robots, a builder of stage sets and machinery for theatrical spectacles, and a scientist who studied physics, anatomy, and, of course, flight. He is our prime example of *l'uomo universale*, the universal or renaissance man.

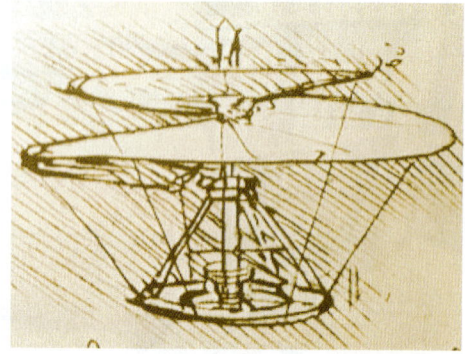

His paintings have been on exhibit and fascinating viewers and scholars for more than 500 years. Some of his work, like the anatomy drawings, changed the way we look at the world. But much, if not most, of his brilliance remained hidden in the pages of his many notebooks until the nineteenth century, while the world struggled through the scientific revolution, unaware that Leonardo had already been there.

Most of the ideas and sketches and studies in his notebooks grew out of work he was doing, or projects he was trying to sell to his patrons. But flight was different. It was something that he did just for himself, and even when it became clear he would never be able to fly himself, he never completely gave up dreaming and drawing.

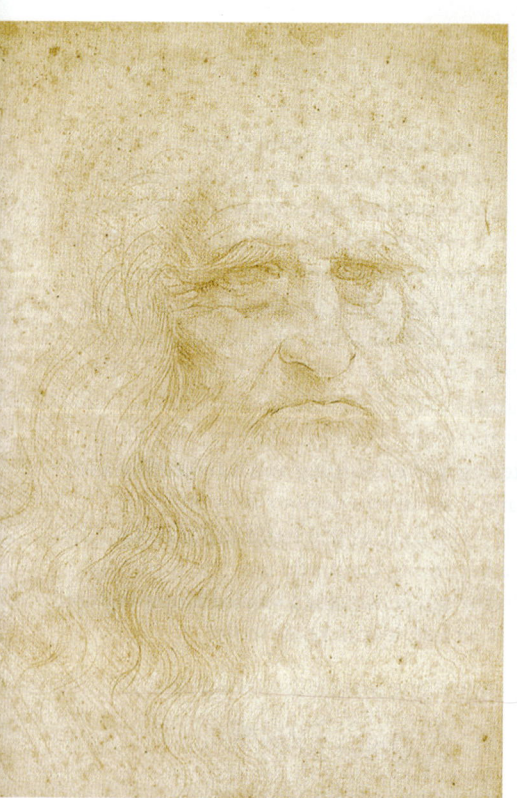

Left: Leonardo da Vinci's portrait, drawn by himself.

Above: The one and only drawing of Leonardo's helicopter.

Facing page: Part of a design for a mechanical wing.

6 Leonardo da Vinci's Flying Machines

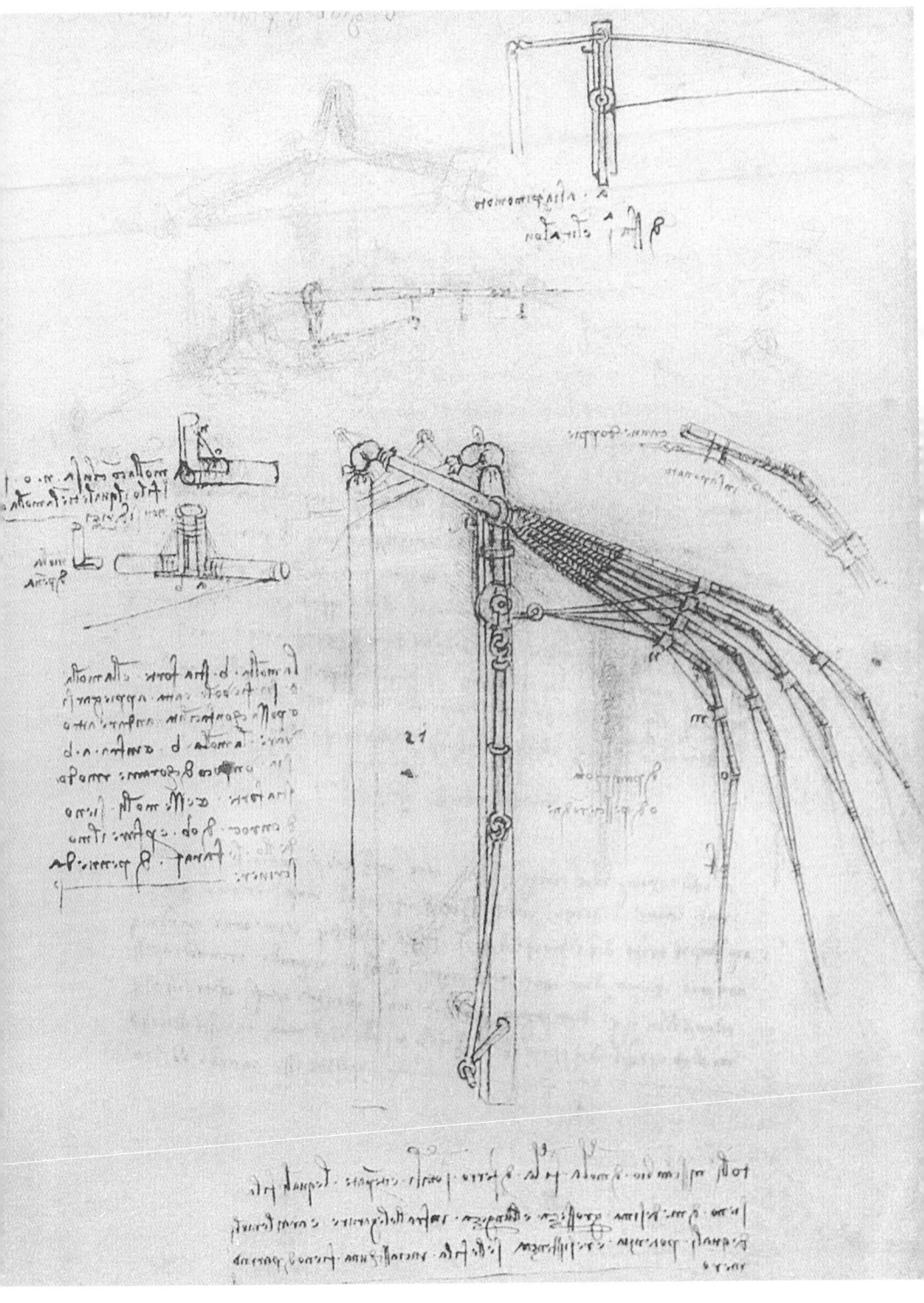

Leonardo's Romance with Flight

Looking at Flying Animals

Birds, bugs, and bats: lots of things in our world fly. We see them every day, and envy their freedom. We long to join them in the air, and so did Leonardo. They make flying look so easy. But try as we might, we can't do it.

Just how do they fly? How can we know?

If this were fifteenth century Italy, Leonardo's world, we'd be without textbooks and labs and internet, and we could only watch and guess.

That's what Leonardo did. He watched, intently and endlessly.

But he probably saw these flying animals very differently than we do. Most of us only see blurred wings. His drawings show birds and bugs stopped in mid-flap, each in a different position. Some scholars suggest that he was able to envision a "frame" of their movement in his mind, as if he was seeing not the smooth motion of a movie, as most of us do, but a series of frozen poses. The animated movie director Hayao Miyazaki can do this, which is why his movies look so realistic. In Leonardo's case, that ability seems to have let him see the wings of birds and insects frozen at each stage of their motion, and understand how they reacted with the air.

The notebooks contain many drawings of flying animals. There are dragonflies, bats, butterflies, a flying fish, and of course the birds. He drew page after page of birds—so many that one whole notebook, the *Codex on the Flight of Birds*, is devoted to them.

Everyone knows that humans can't fly, but that doesn't mean flight is impossible. So wrote Leonardo. Look! The birds can do it, so it can be done. And if we imitate the birds, and learn their secrets, maybe we will find our own way to fly.

Birds, bugs, and bats all fly with wings. Leonardo thought that if we made wings for ourselves, and if they were the right shape and moved the right way, we would be able to fly too.

So, he spent many hours observing birds and insects fly, and sketched all the various stages of their wing movement. Many of the drawings show what looks like wind; in fact he was showing how the air moved over and around the wing, and how it held the birds up. He saw the animals almost as machines, with bones and muscles and joints that could be reproduced in wood and string and fabric.

And the longer he watched, the more he understood. He began to see how machines could be made to fly.

What Leonardo Discovered

The Wright Brothers are often celebrated as the inventors of flight, but what they actually invented was a way to control the airplane in flight. All of the other knowledge they made use of had been gleaned from others. Engines and propellers already existed. Otto Lilienthal had shown how lift (an upward force acting on an object when the air pressure above the object is lower than that below) was created, Alphonse Pénaud had shown how to create a stable airframe, and George Cayley had proved

Facing page: Studies of birds in flight.

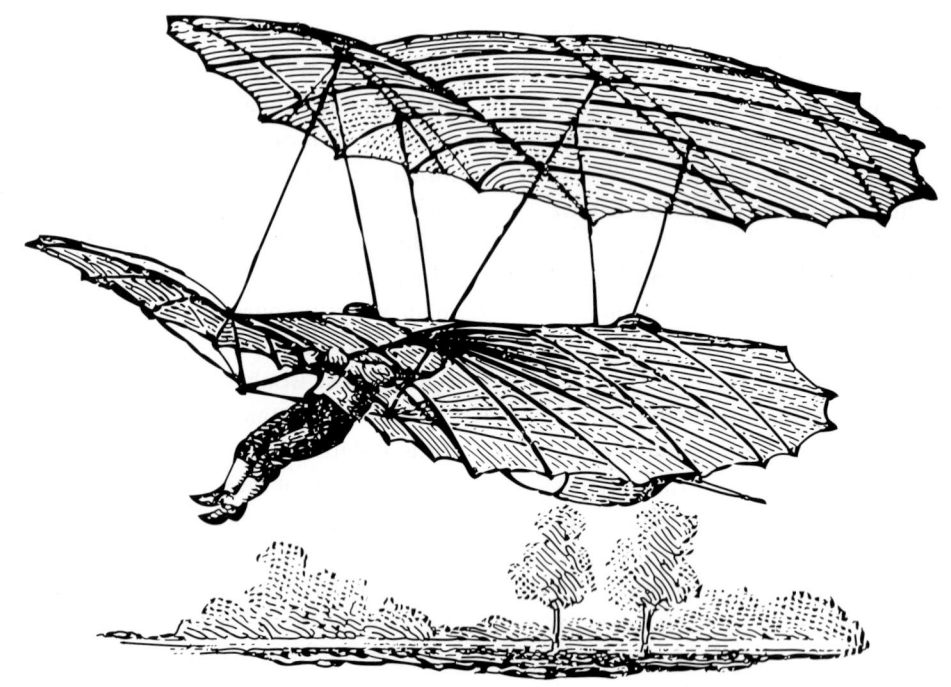

that airplanes could glide. There were also lots of failures, which taught the Wright Brothers what not to do. The brothers just added their own insight to the mountain of knowledge already available.

Leonardo could not do that, because there was almost no one ahead of him. He had to start entirely from scratch.

There were earlier inventors who tried to build wings and fly. Most were "tower-jumpers," people who strapped on simple wings and leapt from windows and bridges. Others used devices like parachutes, and at least one, Eilmer of Malmesbury, is said to have built a glider. Few, if any, of these attempts succeeded. It was obvious to most people that this was a quick way to die, not to fly. Leonardo would have known that lots of ground testing was needed before making a jump.

What else did he know?

He knew that there is air. And he knew that air can hold things up. He knew that paper, leaves, and handkerchiefs can be wafted up by a breeze, and that they fall very slowly when dropped. To fly, he would need to use this power of air.

He knew that birds and bats and insects fly because they have wings. He knew that there is nothing magical about them. Just as people can only

walk if they have legs that are strong and healthy, birds can only fly if they have wings of the right shape and strength.

He knew, from watching hawks, bats, dragonflies, and flying fish, that flapping is not necessary for flight, because all of these animals can rest their wings and glide. He also knew that gliding animals eventually coast down to the ground, unless strong winds waft them up again.

None of this is surprising. Anybody could have seen these things. What is really amazing is what came next.

After years of watching birds, Leonardo learned that it was air flowing around them that holds them up. He had originally thought that flying animals stayed up by pushing down on the air under their wings, the way a person might lift themselves up by pushing down on the arms of a chair. But his wing-testing rig taught him that this was not sufficient for flight, and could not explain gliding. Among his drawings are several that show the center of gravity of birds, and refer to the way balance affects flight. He knew that bird wings have curved surfaces, and that this was important. Several drawings look like explanations of how lift is made. In fact, some scholars think he discovered what we now know as Bernoulli's Principle while watching water speed up while flowing through a restriction. From there it was a short step to seeing the same lifting forces that flowing water creates in the currents of air around a wing.

Bit by bit, through observation and experiment, Leonardo began to understand the secrets of flight.

Learning by Observation

Leonardo lived at a time when the scientific method was still in its infancy. Scholars no longer accepted received wisdom just because it had been passed down from the ancients. They used more observation to learn things for themselves. But rigorous experiments with hypotheses and controlled variables and statistical analysis of data were still mostly a thing of the future.

Leonardo did a lot of observation. As he watched, he would make guesses about why the things he was seeing happened the way they did. The more he watched, the more refined his theory would become, and as he noticed more, he could better judge what must and must not be true.

For example, he knew that birds did not just push air down with their wings, but he also noticed that they twisted them when they wanted to turn. One wing twisted up, and the other down, and the bird turned towards the side of the upturned wing. Why? It must be that the wind is holding that wing down, while the down-twisted wing swings up and forward, he thought, and so it is. Leonardo noticed that birds have small feathers at the front of the wings that look like thumbs, which move as the bird flits about. He guessed that these were to control the flow of air over the wing, and so they are.

Facing page: Da Vinci's visionary ideas sparked innovation and experimentation in the centuries that followed.

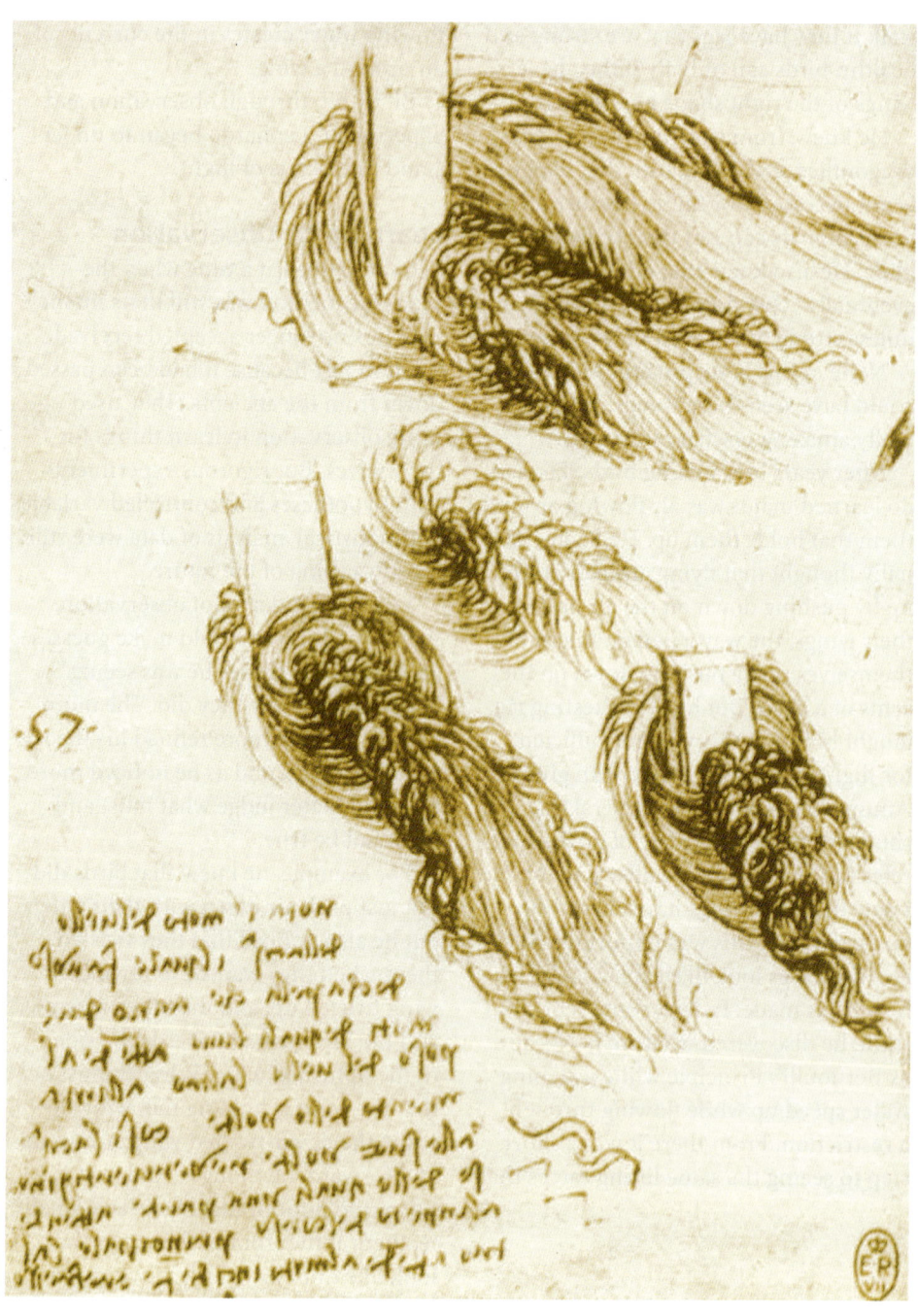

Facing page and above: Studies showing fluid dynamics and the way air acts like water.

12 Leonardo da Vinci's Flying Machines

He seems also to have looked for connections or similarities between things. He noticed, for example, that water and air are very similar when they move, or when things move through them. He was the first person to realize that air is a fluid like water. A boat needs a rudder to stay straight when moving; without one, the boat will turn sideways to the wind or the current. So, he realized, a flying machine must need a rudder too. A board with water moving over only one side of it will be pulled toward the current, so birds' wings are likewise pulled up by strong currents over the tops of their wings. He was very, very close to understanding how the airflow creates a difference in pressure that holds the wing up.

Leonardo also noticed that a man standing in a boat needed to shift his weight to keep the boat balanced, and deduced that by shifting his weight, and therefore the center of gravity, he could control the boat. Could this be done in flight? He watched the birds carefully, and sure enough, they do shift their weight.

These observations let him create an image in his head of what was happening. He often sketched these out. Some

of the sketches just show what he actually saw, but the drawings of birds, in particular, are more schematic, showing forces and currents not visible to the eye.

And, of course, he tested these ideas by making models.

Did Leonardo Make Models?

Leonardo was a painter and sculptor, so models were an important part of his work. The models were made to see how light and shadow appeared on a three-dimensional surface, for example, or to ensure that parts of a mold could be taken apart after making a bronze casting. Models allowed him to check ideas and techniques before starting work on the final piece.

Leonardo was also a set designer who made machinery for large theatrical

Leonardo's Romance with Flight 13

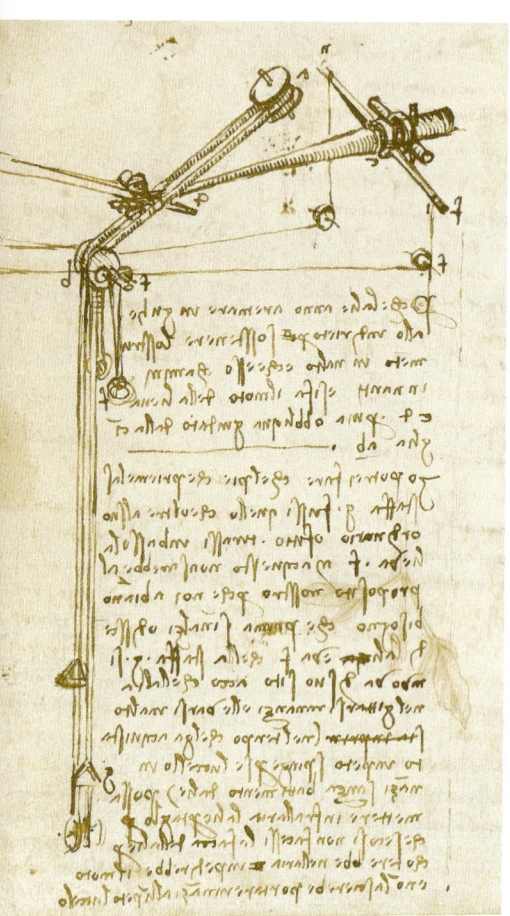

Much later in his life, he was said to have made many tiny toy birds that flew along strings or rose up on jets of air like balloons do when released.

But it seems clear that he must have made some flying models. There are hints in his notes that he built a small version of the helicopter, powered by a spring, which rose up into the air at least briefly as it spun.

Did he build others? No one can say. The notes he left are not clear about this, and no actual models have been found. But it would have been a simple and natural thing for him to cut bits of scrap paper into the shapes of birds and bats and fly them about his workshop.

If he did, he would have learned the importance of balance. The sketches and drawings in his notebooks explore the shapes and structures of wings, but it is hard to imagine that the kite glider, for example, could have occurred to him without some playing with paper and scissors. Neither the glider, nor the other kite-like flying machine drawn on the same page, look quite like anything in nature.

So it seems likely that Leonardo made small models of his flying machines, and learned some of the secrets of flight from them, by actual trial and error.

Testing the Limits of Human Strength

In Leonardo's day, there were really only four sources of power people could use to do work:
- Animals
- Wind
- Water
- Human strength

spectacles, including lion and knight automatons which moved on their own like wind-up toys. It is unlikely that he would have been able, let alone allowed, to jump right into building these huge machines without making models first to prove that they would work.

The wing-testing rig is just such a model. It may be very large as he drew it, but it was still intended only to test whether a wing could produce enough lift to pick a man up off the ground, before he committed himself to designing a whole flying machine.

14 Leonardo da Vinci's Flying Machines

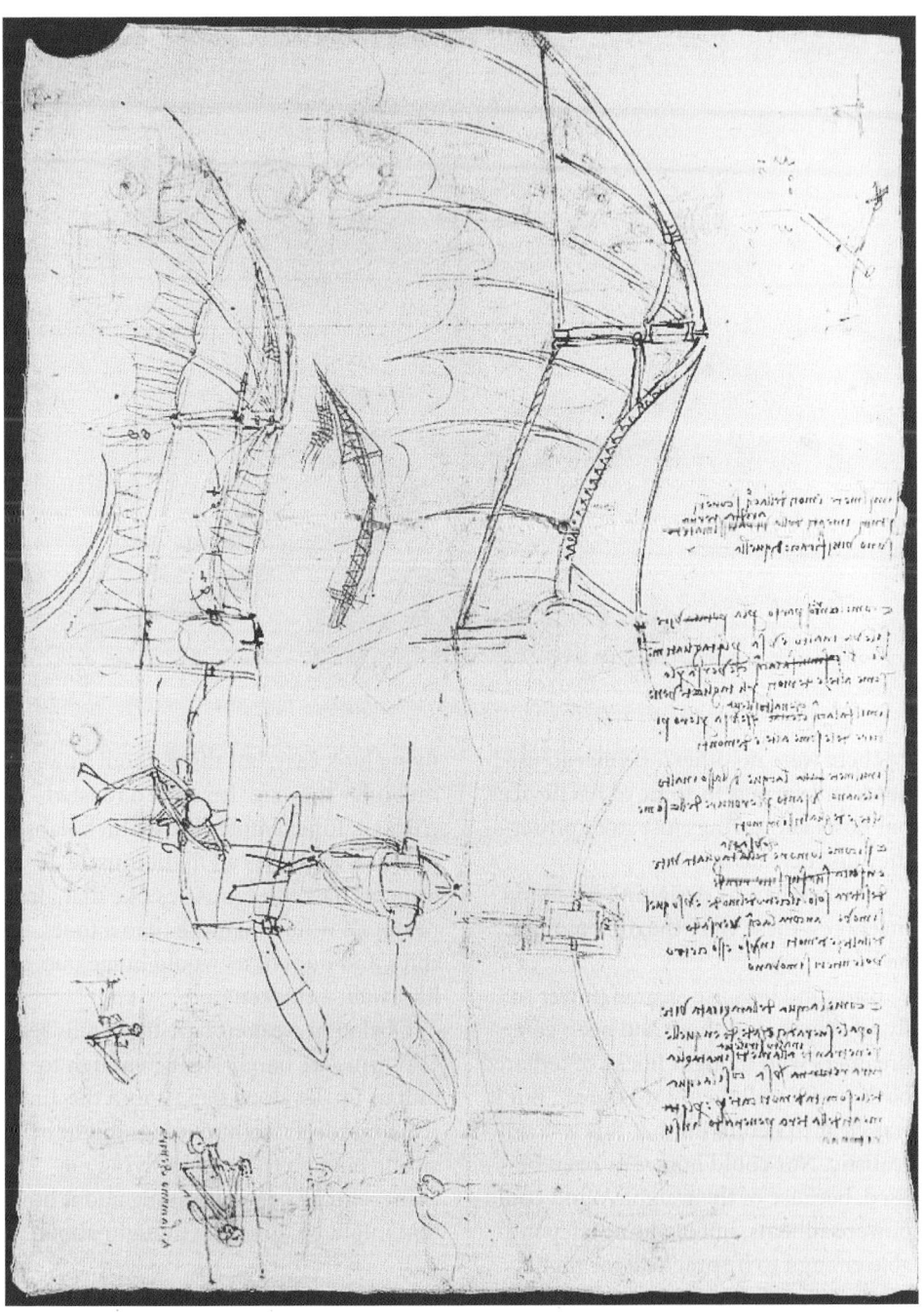

Above: Ornithopter wing and harness sketches.

Facing page: Ropes and pulleys were needed to move mechanical wings.

Leonardo's Romance with Flight 15

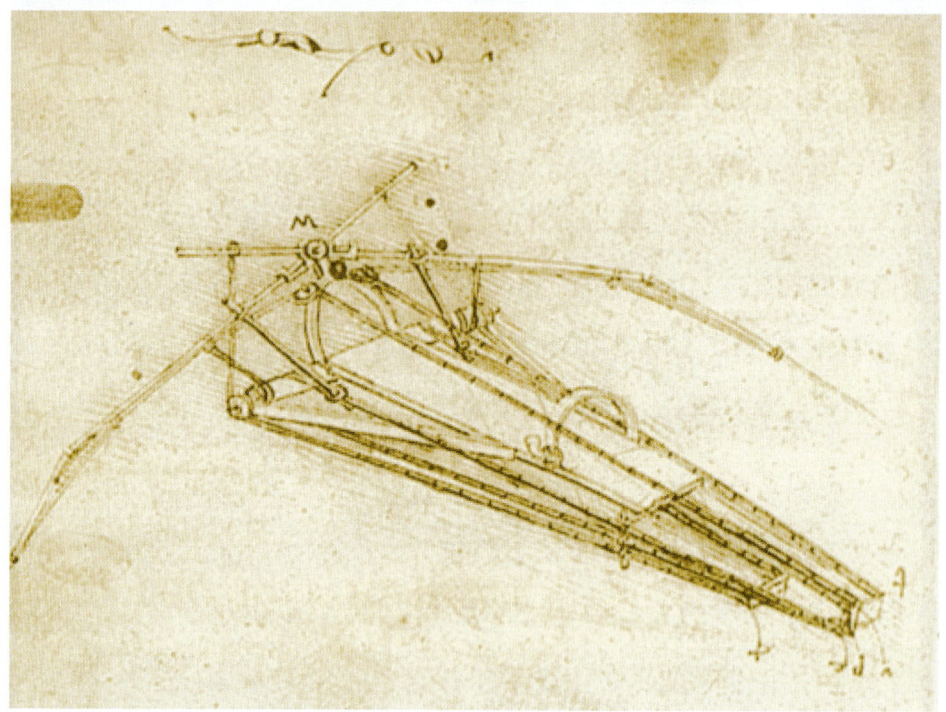

There were no others. Leonardo used bows and springs in some of his devices, but bows and springs just store power—they don't create it.

So when he was designing his flying machines, these were the only options he had.

Birds and bats use animal power to fly, of course, and there had been early dreamers who thought flocks of tethered birds might pull them into the air, but it was clear to Leonardo that this was not realistic. Nor could horses or oxen be used, because of the weight. Wind could power sailboats, but it was not dependable enough to be practical for flight. Water was right out of the question. So that only left human power.

Flight requires a lot of power; much more than you would think. Birds make flying look easy, but think about how muscular they are. Imagine a roasted chicken, for example. Those thick slabs of breast meat? It's all flight muscle. If humans had chest muscles like that, our pectorals would be more than a foot thick and our chests would bulge out like, well, a chicken's.

Obviously, we don't have those muscles. Our arms are barely strong enough to pull us up, let alone flap us into the air.

Leonardo thought our legs might be strong enough to propel a flying machine, and he began thinking about how that might be done. He thought about

Above: The complete prone ornithopter, shown without fabric on the wings.

Facing page: Leonardo's first ornithopter design, with wings like a dragonfly's.

16 Leonardo da Vinci's Flying Machines

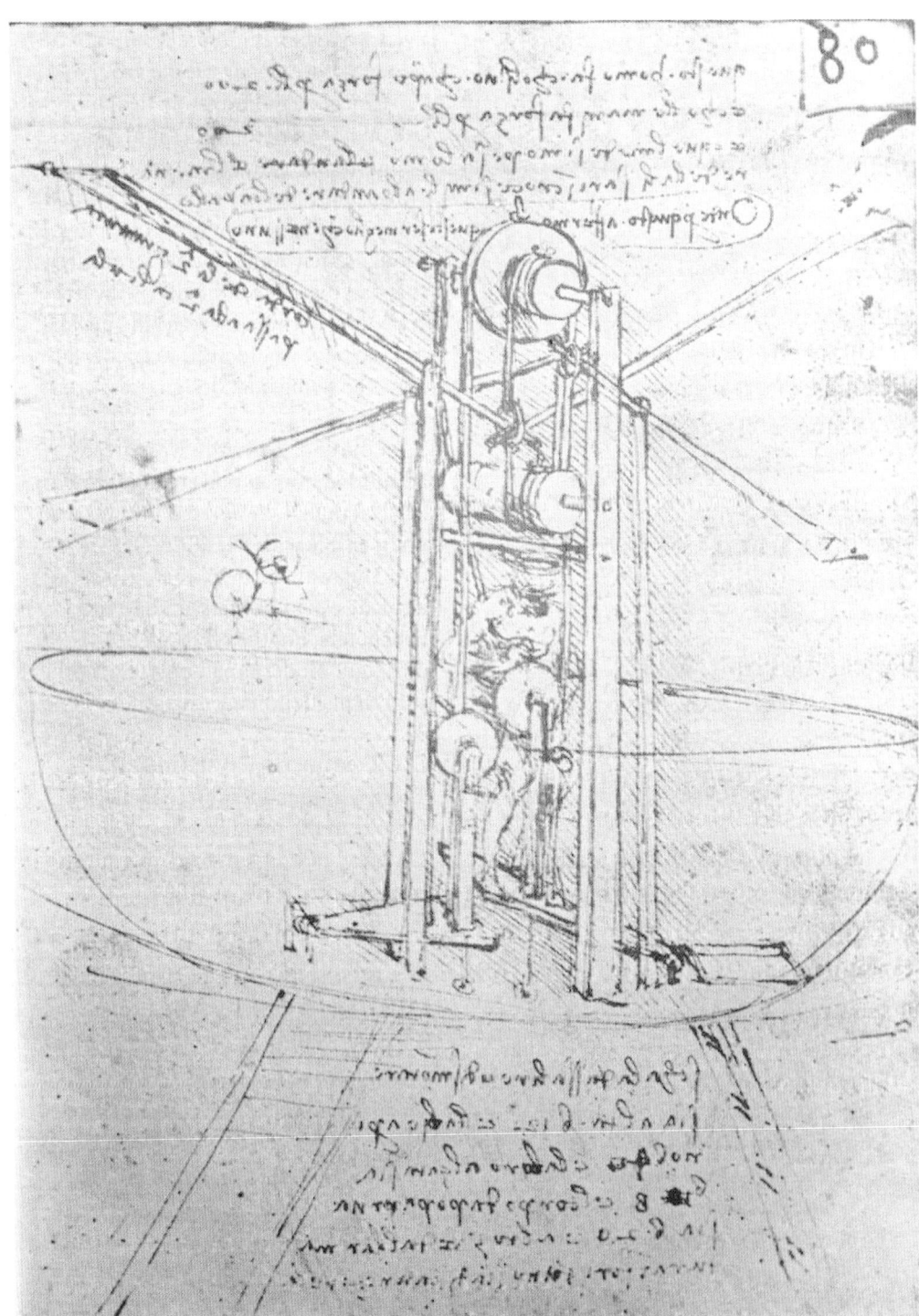

Leonardo's Romance with Flight

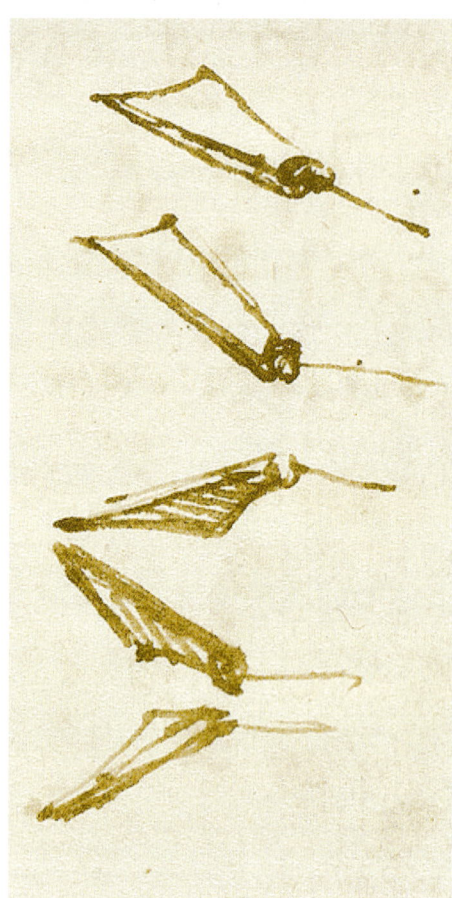

building an ornithopter, a machine that would fly by flapping its wings like a bird.

The first design looked like a large bowl with dragonfly wings at the top. The pilot stood inside a frame with pulleys and pedals to move the wings. In the drawing, the pilot is so small and surrounded he is hardly visible; that ornithopter was clearly much too heavy.

Next, he had the pilot lie prone on a board and move his legs as if climbing stairs. The wings were articulated to both flap and twist, the way birds' wings do. The design looks quite ingenious and even workable. But there would not be enough power to get off the ground.

He needed to find a way to amplify the pilot's strength. Ropes and pulleys could multiply the force sent to the wings, but the more pulleys he used, the slower the movement of the flapping. He thought then about double screws, but this had the same difficulty as the pulleys. A lever could increase the power, but the pilot would need to anchor his feet. The flying boat design uses screws and levers.

In the end, Leonardo was forced to admit that human power alone would not be enough. Powered flight was just not possible with the technology of his day. Today, there are human-powered airplanes, ornithopters, and even helicopters, but they fly only because of ultralight modern materials, and at the very limits of human strength.

Did Leonardo Fly Himself?

There is a legend told in the village of Fiesole, in the mountains overlooking Florence, that a giant bird once arose from Monte Ceceri and flew into the distance, never to be seen again.

What was it?

Could it have been Leonardo, testing a flying machine?

On the 18th page of his *Codex on the Flight of Birds*, Leonardo wrote, "From the mountain that bears the name of the great bird, the famous bird will take its flight and fill the world with its great fame."*

*Translated by E.W. Dickes in 1938.

18 Leonardo da Vinci's Flying Machines

That mountain would likely be Monte Ceceri, whose name derives from the old Florentine word *cecero*, meaning "swan." Monte Ceceri overlooks Florence, and is the highest peak nearby. The summit is open, drops away to an old quarry far below, and is just about perfect for paragliding. If Leonardo ever actually flew one of his machines, this is where he would have launched the "famous bird."

But flying a lightweight paraglider off the precipice, and leaping with a heavy wood-and-canvas glider, are two very different things. Leonardo would have known he needed a lot of speed to get airborne. That would take a lot of strength, and would require considerable luck, too. He could have had a hapless assistant make the attempt, but it would have been far too dangerous to try himself.

The notebooks tell us he intended to make a flight from the mountain. But did he?

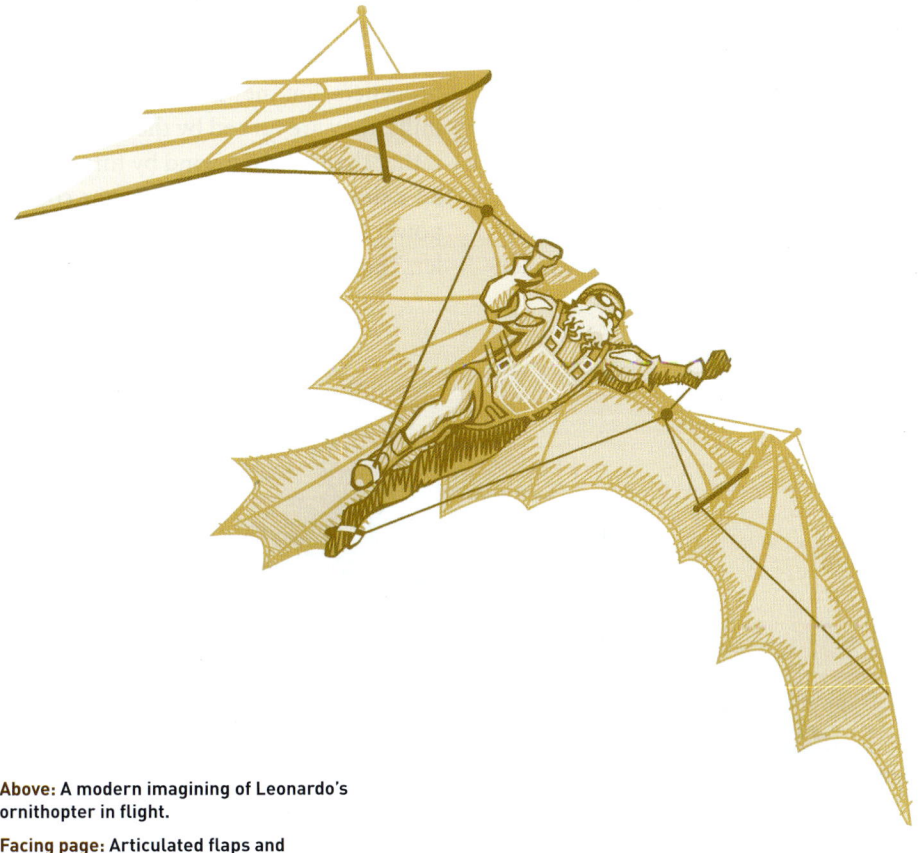

Above: A modern imagining of Leonardo's ornithopter in flight.

Facing page: Articulated flaps and rudders would have been used to control a vehicle in flight.

Leonardo's Romance with Flight 19

There is a note from towards the end of his burst of work on flying machines, found in the *Codex Atlanticus*, that laments the futility of many of his efforts. "*O Leonardo, perche tanto penate?*" he writes. Oh Leonardo, why do you torment yourself so? Leonardo was very tenacious, and kept studying the flight of birds for many more years. But these are not the words of a man who has succeeded in taking to the air.

What Leonardo Didn't Know

Leonardo learned a lot from observation and trial-and-error. He knew that air is a fluid and that it flows over wings. He knew that birds and insects use a complicated figure-eight motion, and not just up-and-down flapping, to both lift them up and push them forward. He knew that birds, and therefore aircraft too, could glide without flapping. He knew that his machines had to be made much lighter in order to fly.

But there was a lot he did not know.

He did not know how to get off the ground. His parachute and the gliders were launched by jumping from a high place, but the ornithopters had no landing gear and no way of rising into the air. Small birds use brute strength to leap into flight, but he would have seen larger birds like geese and swans running faster and faster until they had enough speed to get airborne. It seems to have never occurred to Leonardo to add wheels to his machines.

He did not know of any way but flapping to create thrust. Some of his drawings show devices that look like propellers, but they are always windmills; they are turned by the wind, rather than creating wind by turning. So it did not occur to him that he could power his machines by turning a propeller. Though, to be honest, human power

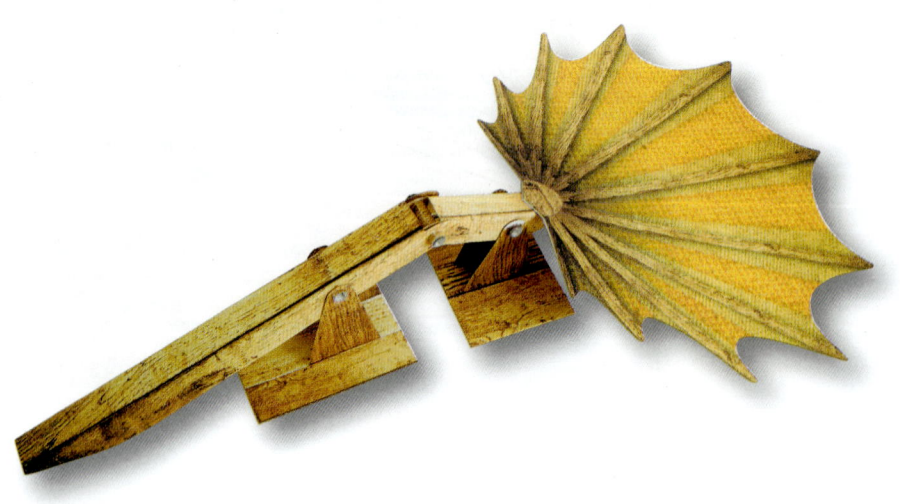

Leonardo da Vinci's Flying Machines

would not have been sufficient to pull his heavily-built aircraft.

But the scope of what he did not know was, surprisingly, quite small. He had most of the knowledge and ideas needed to fly. And with better materials to make very much lighter machines, he could well have succeeded.

Another thing Leonardo never knew: several of his designs have been built in recent years, and successfully flown.

After his death, Leonardo's notebooks were hidden away by his executors to protect them, and as a result, they were virtually unknown until the nineteenth century. By that time, it was much too late for all of the knowledge and ideas in those thousands of pages to affect the development of technology. But several people have looked at his designs and thought they were practical enough to actually try them out.

In 2002, Robbie Whittall and the University of Liverpool built a hang glider based on Leonardo's kite glider design, and Whittall's successful flight was broadcast by the BBC. He had to add a vertical fin, though, to make it stable enough to fly.

In 2003, champion hang glider pilot Judy Leden flew a glider built by Steve Roberts, based on some of Leonardo's sketches, for an English TV show. She succeeded, but only barely, and said later that first-time pilot Leonardo would have crashed right away.

And in 2000, skydiver Adrian Nicholas built a parachute to Leonardo's specifications, using only tools and materials that he would have had, and jumped with it from a hot air balloon over

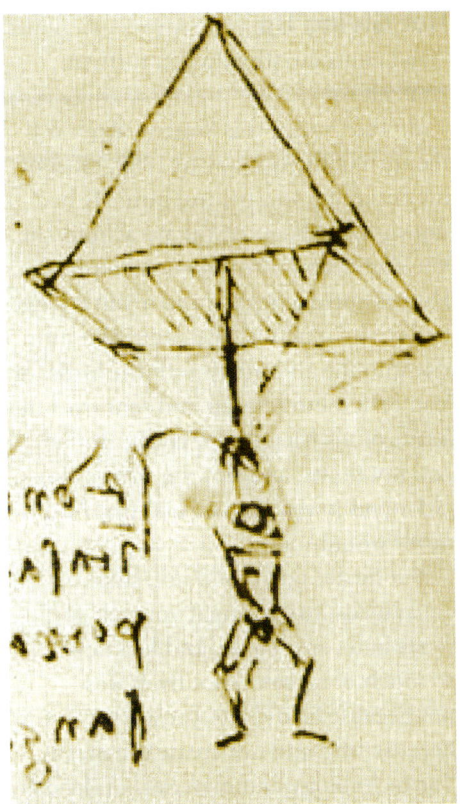

South Africa. Not only did it work, but it worked well. Nicholas declared it the smoothest parachute he had ever used. "It took one of the greatest minds who ever lived to design it, but it took 500 years to find a man with a brain small enough to actually go and fly it," he said.

If only Leonardo had known!

Above: Leonardo's drawing of the parachute.

Facing page: This kit's version of Leonardo's Wing-Testing Rig (page 50). Different wing designs would have been mounted onto the actual device to determine their capability to generate thrust.

Leonardo's Romance with Flight

Not Giving Up

"Oh Leonardo, why do you torment yourself so?"

By the time of this lament, around the turn of the century in 1500, most of his designing was behind him. He had drawn the helicopter, the parachute, the kite glider, and all of the ornithopters. He had spent a decade and a half trying to devise a machine that would let him rise into the air and fly with the birds, or leap off a mountaintop and soar over the heads of his friends and rivals. But he had not flown, and now he was getting older and it was clear to him that he never would.

But he did not, could not, stop.

"Why do you torment yourself so?"

He had come so far, and he knew so much. If he could not fly, it was not because he did not know how, but because he could not create the means. The technology and materials of the day were too crude and heavy to make lightweight machines with enough strength to be able to carry him aloft. (It has only become possible, barely, in the past few years.) He was frustrated, but he had come too far to completely give up.

And so he carried on with his studies, watching birds and working on the *Codex on the Flight of Birds* and thinking about flying for two more decades.

Leonardo wrote in one of his anatomical notebooks, "Though human ingenuity may make various inventions which, by the help of various machines answering the same end, it will never devise any inventions more beautiful, nor more simple, nor more to the purpose than Nature does; because in her inventions nothing is wanting, and nothing is superfluous, and she needs no counterpoise when she makes limbs proper for motion in the bodies of animals."*

No flying machine he designed could ever match the perfectly adapted bodies of birds and bats. Nor were human limbs appropriate for flying. But this does not mean that humans cannot devise such machines at all.

Humans, then, would never achieve the beauty and efficiency of flying animals, but with ingenuity enough, people could still make wings sufficient for flying. Humans would have to add wood and canvas, rope and pulleys to the weak arms and legs nature had given us.

So, Leonardo did not despair. If he could not find the way to fly, some day some other person surely would.

*Translated by Jean Paul Richter in 1883 from W. An. IV 184a, part of the RL manuscript at Windsor.

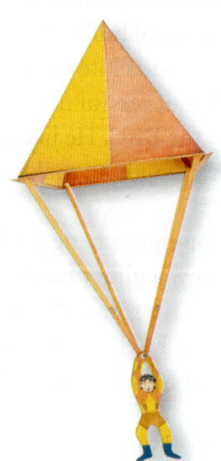

Above: See page 40 for a functioning parachute model!

Facing page: The structure of the wings Leonardo envisioned had the long fingers and fabric membranes of bat wings, rather than the feathered wings of birds.

22 Leonardo da Vinci's Flying Machines

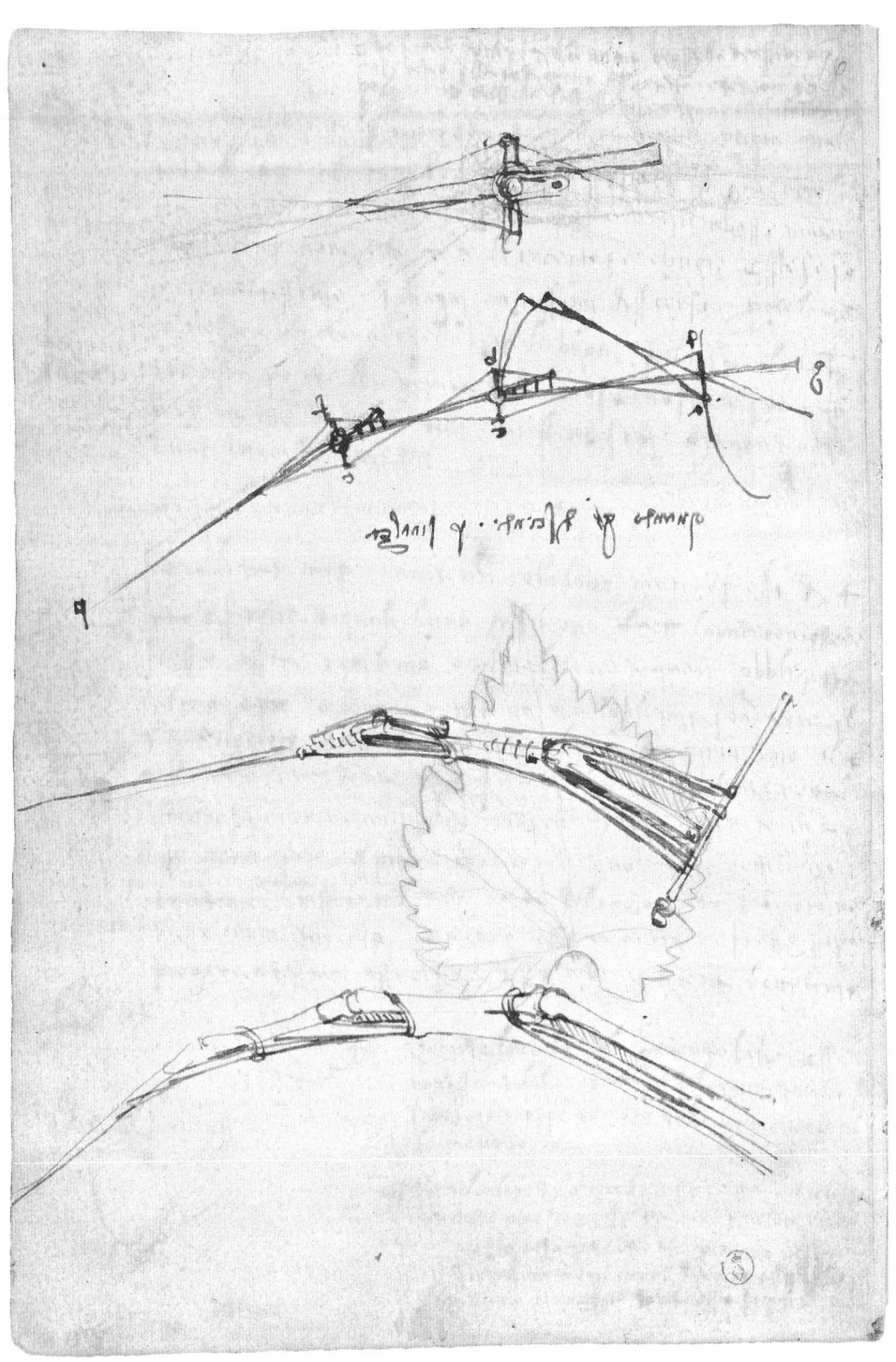

TOOLS AND TECHNIQUES

Tools Required

These are the tools—the only tools!—you'll need to make and fly the planes.

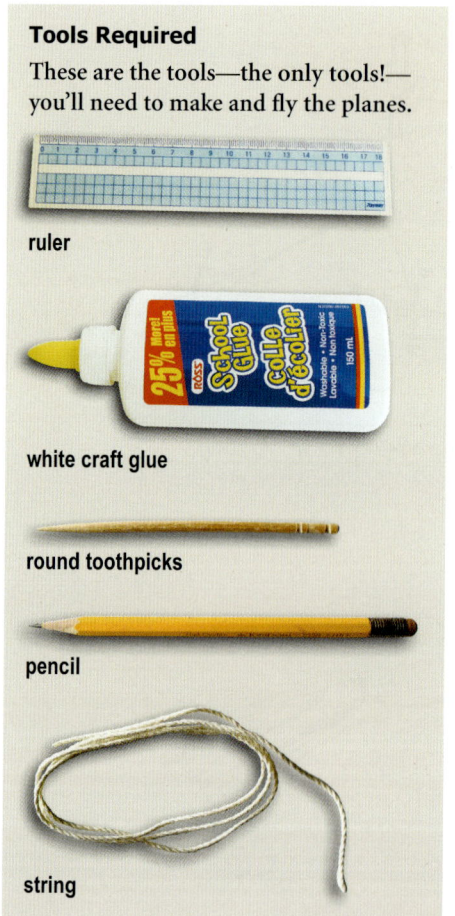

ruler

white craft glue

round toothpicks

pencil

string

Mountain Fold vs. Valley Fold

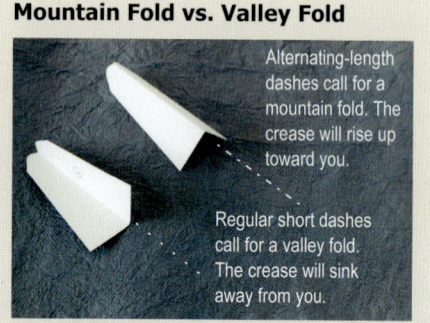

Alternating-length dashes call for a mountain fold. The crease will rise up toward you.

Regular short dashes call for a valley fold. The crease will sink away from you.

Popping Out the Model Pieces

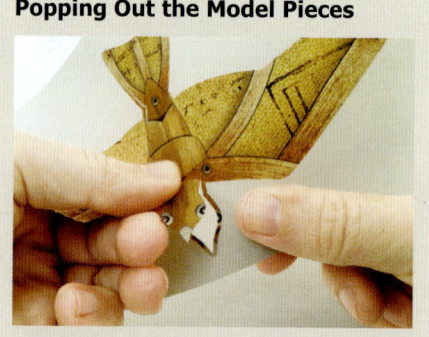

Push or pull the perforated parts out of their sheets slowly and carefully with your fingers. Be careful not to tear or crease the parts as you pull them out. If a part gets torn slightly, don't worry. You can glue a tiny bit of scrap paper on the back as a patch.

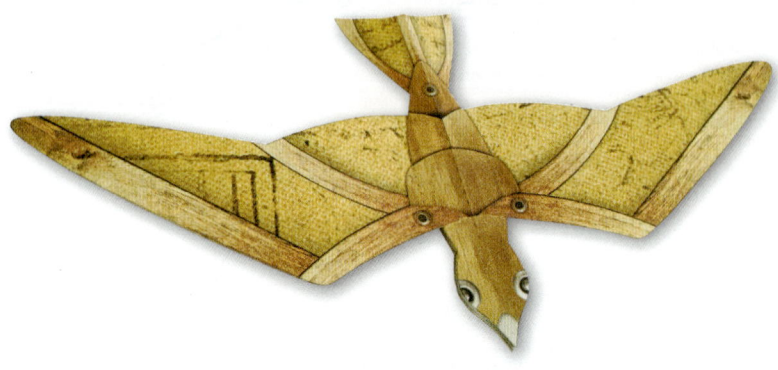

24 Leonardo da Vinci's Flying Machines

BASIC FOLDING TECHNIQUES

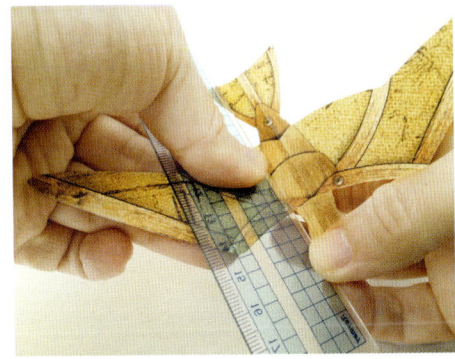

Use a ruler when you fold the paper. This will give you crisp, straight creases without weakening the paper.

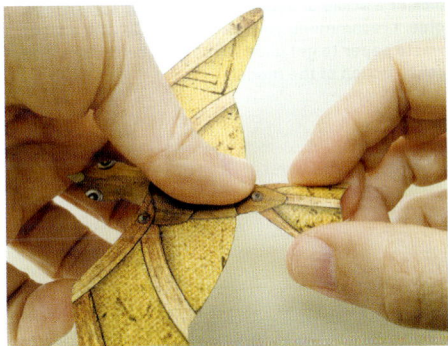
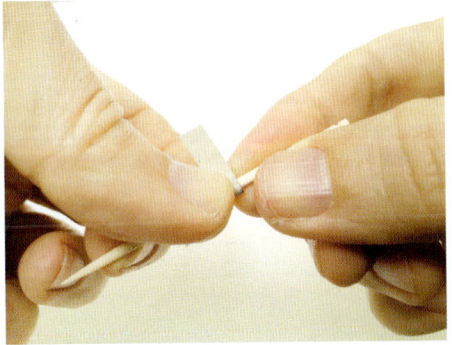

Once you've creased the paper, use your fingers to gently fold it to just the angle you need.

Use a round toothpick to help you roll up axles and ballast roll parts. Roll the paper around the toothpick as tightly as you can, and straighten the roll as you go.

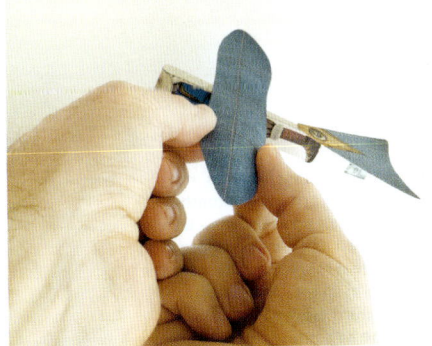

Gently bend the wings with your fingers to "train" *camber* (a gentle curve) into the paper. Camber increases lift and encourages longer glides with fewer stalls.

BASIC ASSEMBLY TECHNIQUES

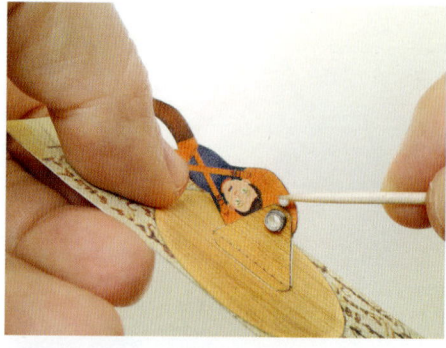

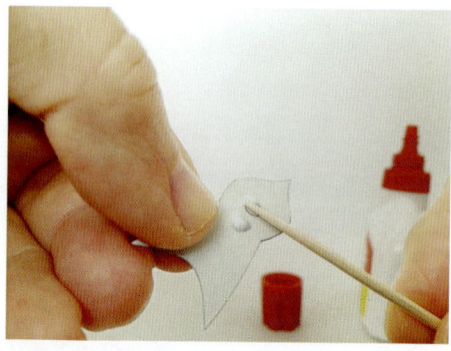

When gluing the axles, carefully slip them into place before you glue them. Use a toothpick to dab a tiny bit of glue into the corner between the axle and the edge of the hole. Be careful not to get glue on the moving part!

You don't need to use very much glue. In fact, too much glue warps the paper and makes it soggy and smudged. Use a small dab or bead, and spread it out very thinly over the whole area to be glued. A toothpick or a scrap of paper works well for spreading the glue. I recommend you practice a little with a bit of waste paper to get used to the glue before starting construction of the model.

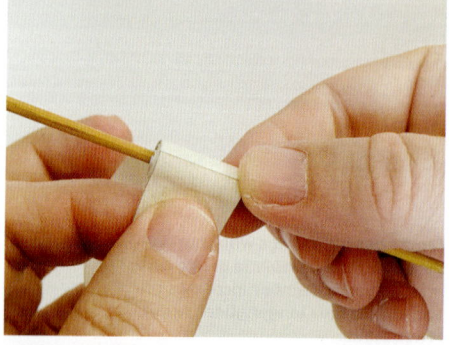

When rolling ballast or axles, roll them as tightly around the toothpick as you can. Roll one piece at a time. A very tiny bit of glue at the very end, spread with a toothpick, will hold the first piece in shape. Add the second and then third pieces with a bit of glue at the beginning and end.

26 Leonardo da Vinci's Flying Machines

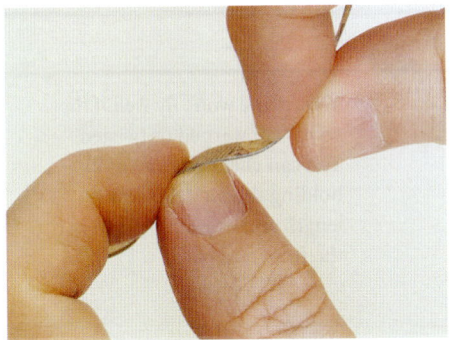 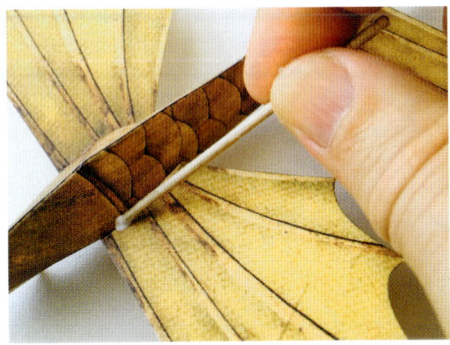

Bend the paper carefully with your fingers to "train" it before gluing it. And then, while the glue is still not quite dry, shape the part carefully with your fingers again.

The wings and tail of the Flying Fish have no glue tabs, so you need to hold them in place with a small fillet of glue. Add a dab of glue at the corner between the wing and fuselage, and spread it evenly along the whole joint with the tip of your finger or a toothpick. Be sure to clean your fingers before you touch the plane again!

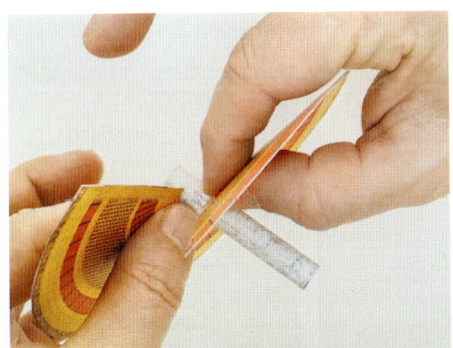

The wings of the Helicopter and Flying Screw need a bit of extra care when gluing them to their cores. Spread glue in a half-inch area around the dotted line on the core. Slip the wing over the core, and pull the edges up and down to exactly meet the ends of the dotted guideline. Press down the "teeth" to fasten the wing into place.

Basic Assembly Techniques

TEST-FLYING YOUR PLANES

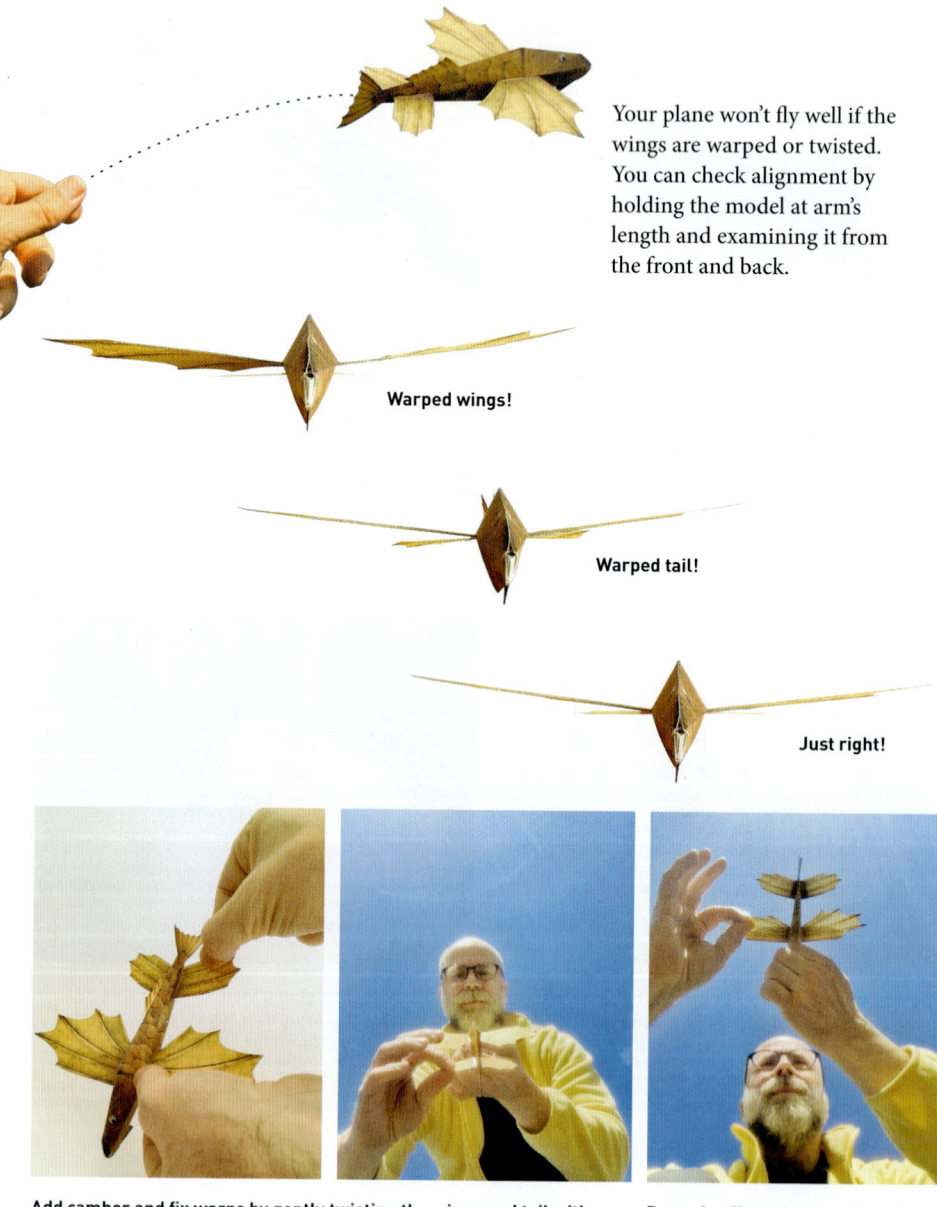

Your plane won't fly well if the wings are warped or twisted. You can check alignment by holding the model at arm's length and examining it from the front and back.

Warped wings!

Warped tail!

Just right!

Add camber and fix warps by gently twisting the wings and tail with your fingers. Tweak a tiny bit at a time until everything is straight.

Paper is affected by moisture in the air and sunlight, both of which can warp the paper slightly, so you should re-check the planes just before flying them, and again every few flights.

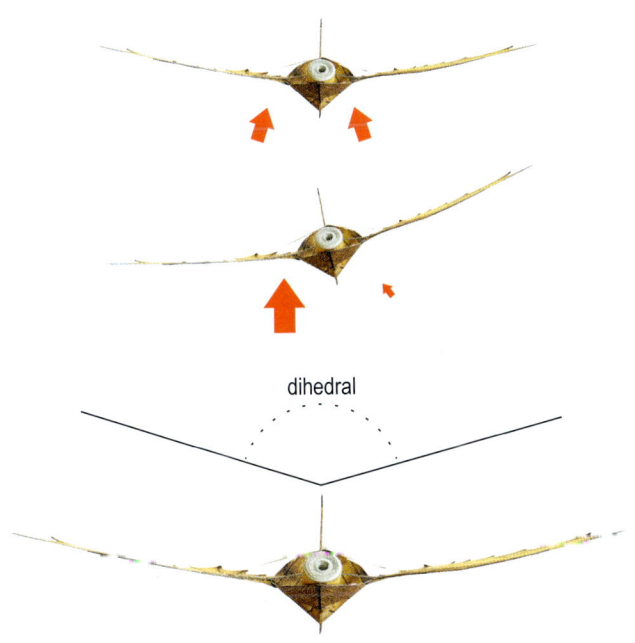

dihedral

The upturn of the wings is called *dihedral*. It helps keep the plane level, because lift pulls at right angles to each wing, and when the plane banks, the lift created by the level wing increases, and straightens the whole plane until the lift is equal again. Delta-winged planes like the Kite Glider don't need dihedral, because the basically triangular wing shape has the same effect, but most of the planes in this kit should have a little.

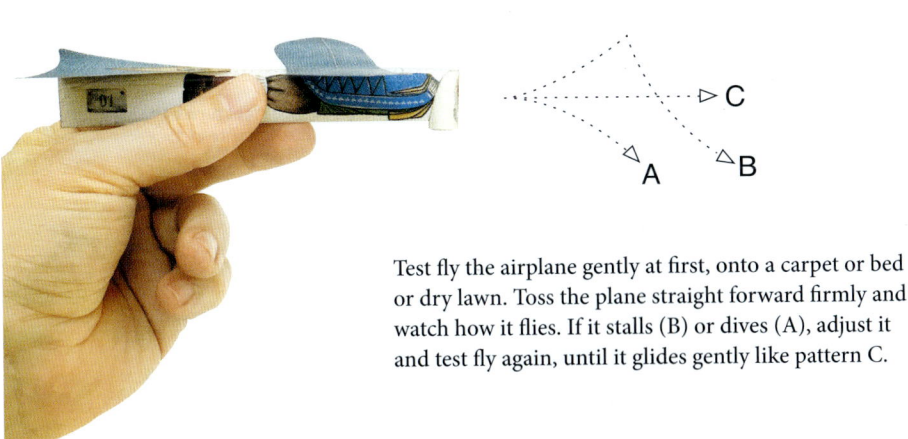

Test fly the airplane gently at first, onto a carpet or bed or dry lawn. Toss the plane straight forward firmly and watch how it flies. If it stalls (B) or dives (A), adjust it and test fly again, until it glides gently like pattern C.

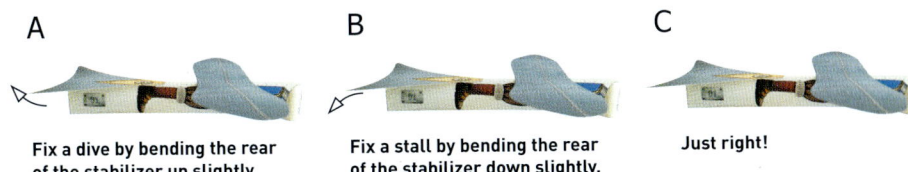

A — Fix a dive by bending the rear of the stabilizer up slightly.

B — Fix a stall by bending the rear of the stabilizer down slightly.

C — Just right!

Test-flying Your Pkanes 29

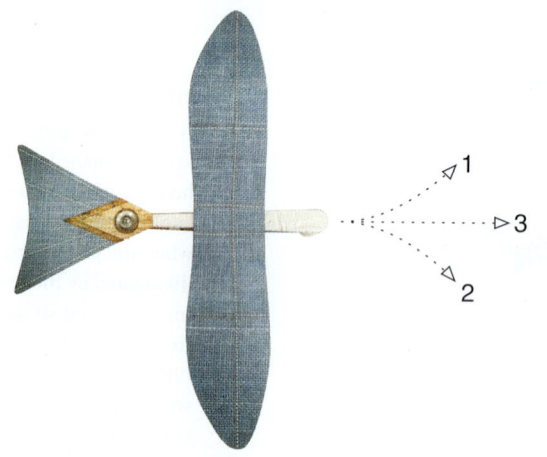

If the plane turns to one side or the other, adjust it until it flies straight, as in pattern 3.

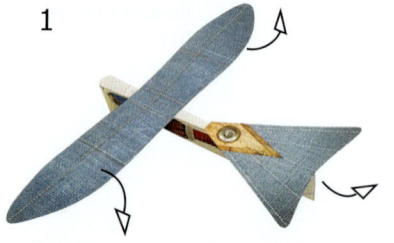

If the plane turns left, slightly bend the rear edge of the left wing down, bend the rear edge of the right wing up, and bend the rudder to the right.

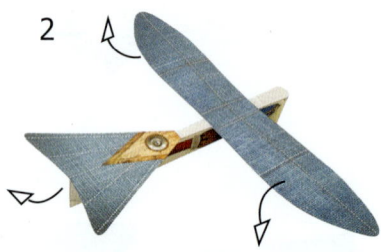

Fix a right turn by doing the opposite of 1.

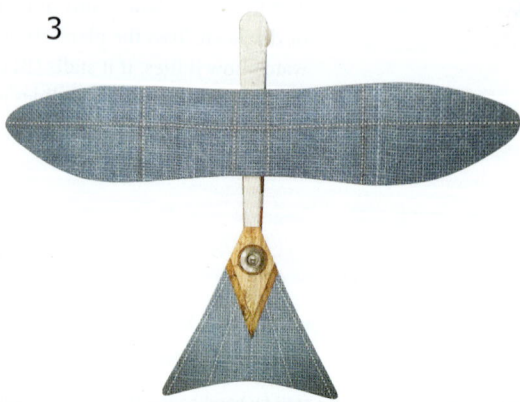

Just right!

Leonardo da Vinci's Flying Machines

HOW TO HOLD THE PLANES

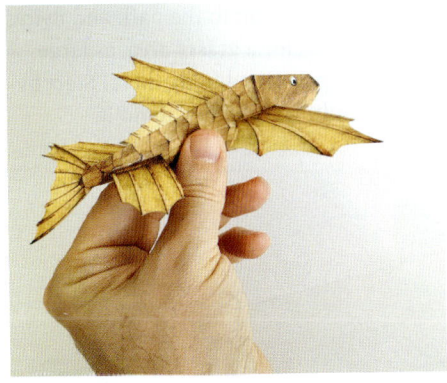

When test-flying, or flying a plane gently toward a curtain indoors or out on a small lawn, it is best to hold it gently where it balances easily between your thumb and index finger. Throw it gently but firmly straight ahead, as if you are throwing a dart.

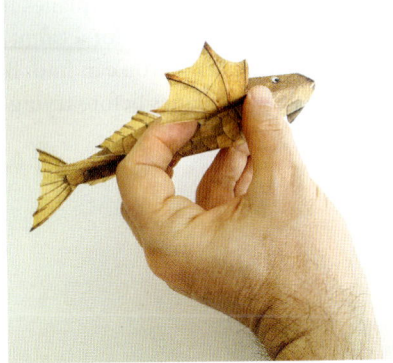

For a stronger launch, the best way to hold the plane is to grip the nose with your thumb and ring fingers, while resting your index and middle fingers at the back of the wings. This will support the plane and keep it pointing straight ahead while you give it a good push, followed by a smooth follow-through!

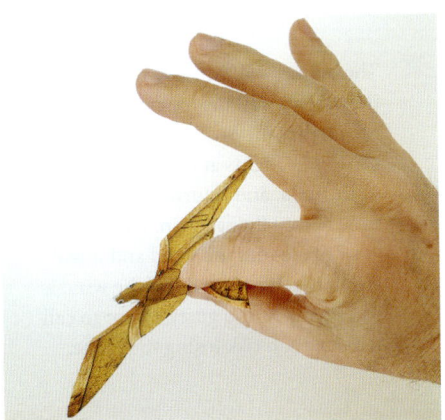

Hold the Flitting Bird as shown, and push it gently straight ahead. Too fast and it will pop up and stall, but too slow and it will fall to the floor. Give it a few practice tosses, and you'll get the hang of it!

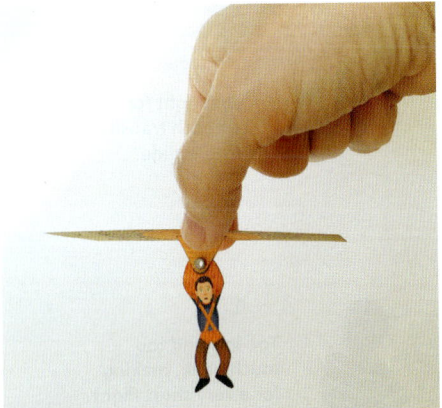

The Falling Leaf glider is probably the easiest of all. Hold the sides of the wing as shown, and let it fall. Voilà!

31

HAND-LAUNCHING YOUR PLANES

Once you have test-flown your airplanes indoors, try taking them to the park and flying them outside. You should wait for a calm, dry day, and look for a grassy area, as large and obstacle-free a park as you can find. Be sure you are permitted to fly there! Start by hand-launching your planes before trying out the catapult. Here is how to do it.

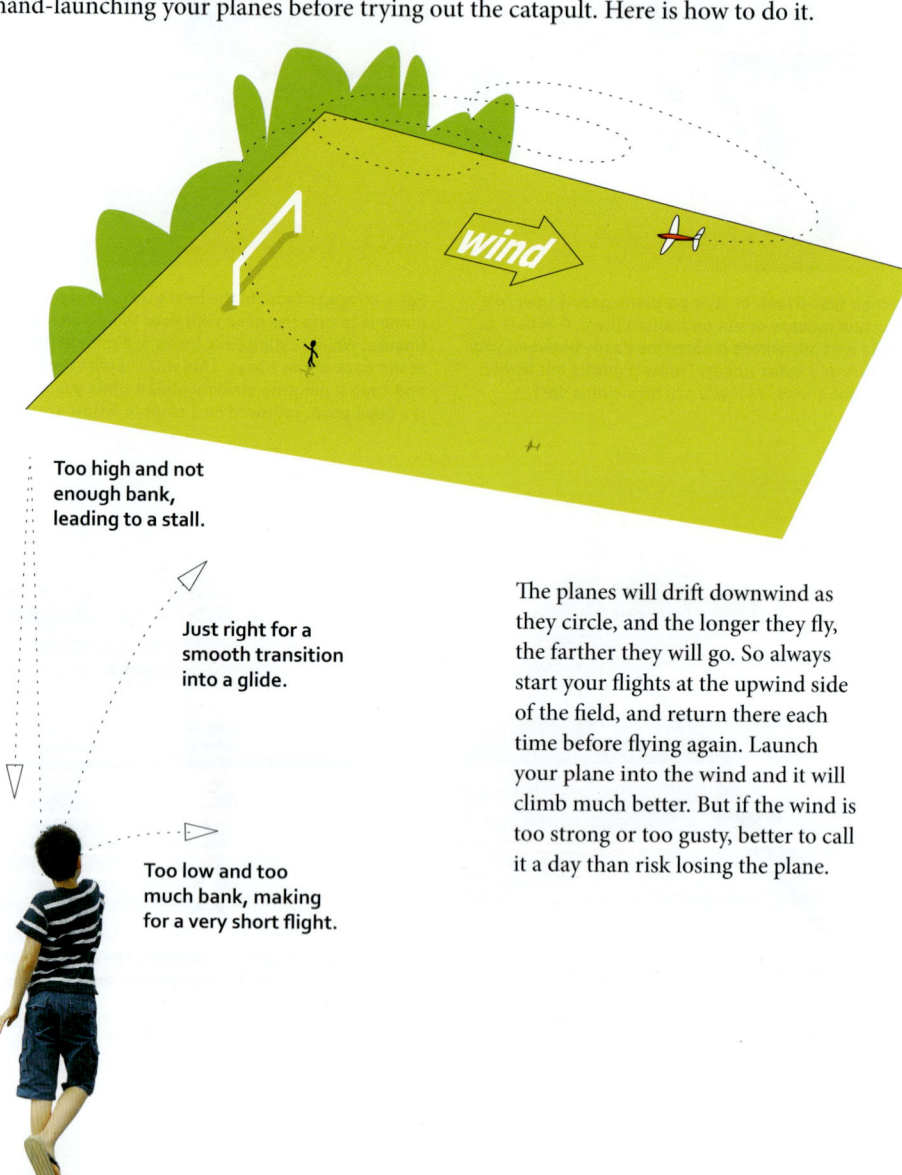

Too high and not enough bank, leading to a stall.

Just right for a smooth transition into a glide.

Too low and too much bank, making for a very short flight.

The planes will drift downwind as they circle, and the longer they fly, the farther they will go. So always start your flights at the upwind side of the field, and return there each time before flying again. Launch your plane into the wind and it will climb much better. But if the wind is too strong or too gusty, better to call it a day than risk losing the plane.

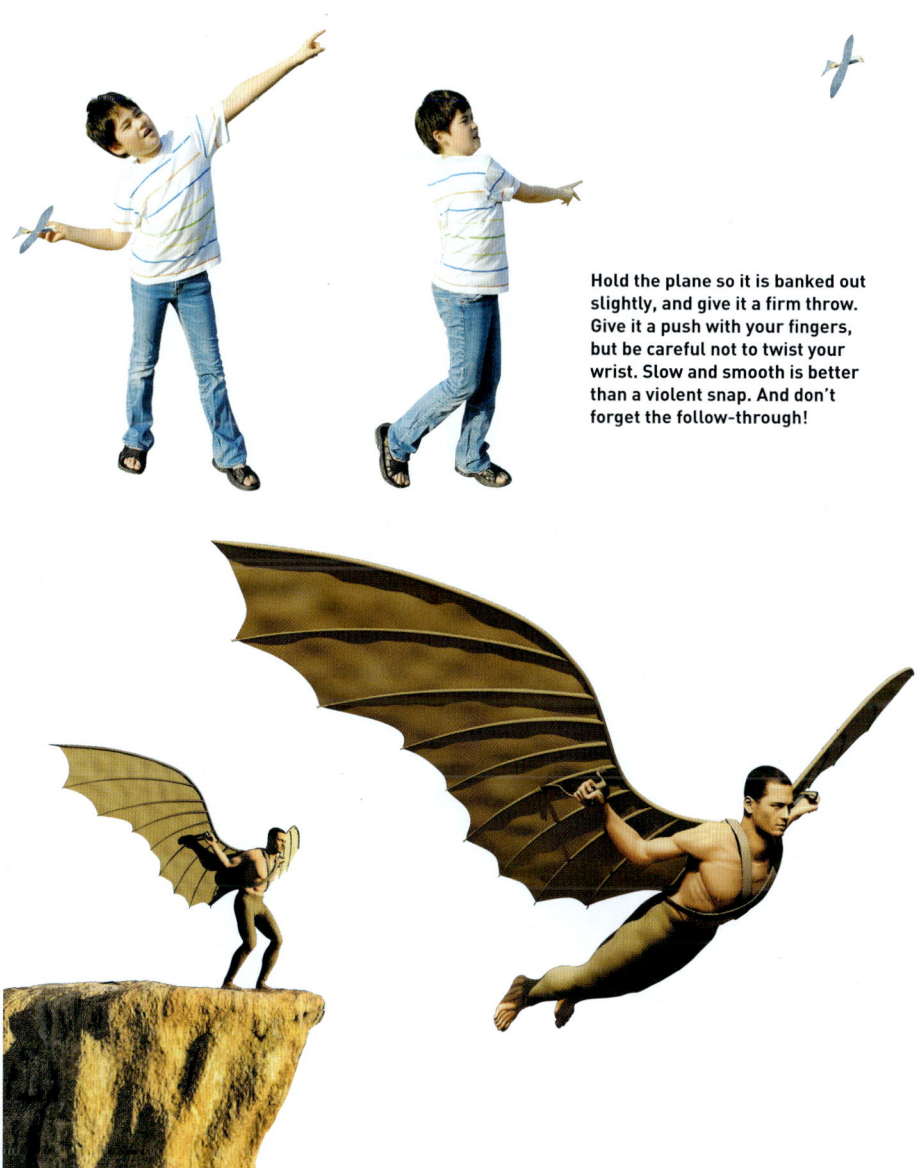

Hold the plane so it is banked out slightly, and give it a firm throw. Give it a push with your fingers, but be careful not to twist your wrist. Slow and smooth is better than a violent snap. And don't forget the follow-through!

WARNING—Fly Safely!

Your paper airplanes will fly much faster and farther than you expect. And they can be dangerous if they hit people. Never fly close to trees and power lines, or climb into them to retrieve your plane; the danger isn't worth it. Stay away from roads and cars. And never, ever point the planes at people or animals. I also recommend wearing glasses or sunglasses and a hat when flying, for your own safety.

Hand-launching Your Planes

USING THE SLINGSHOT LAUNCHER

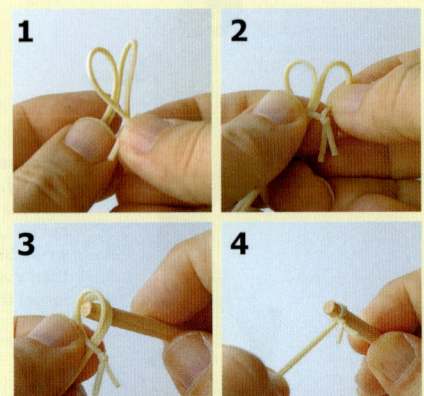

The preassembled launcher comes with about 18 inches (50 cm) of rubber band (model airplane rubber motor stock). To replace the rubber band, knot new rubber motor stock into a loop, and then tie the loop to the dowel as shown. Give it a good pull to tighten the knots.

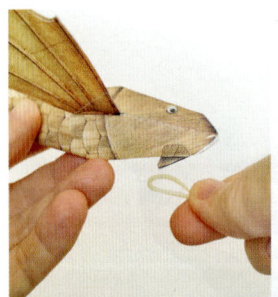

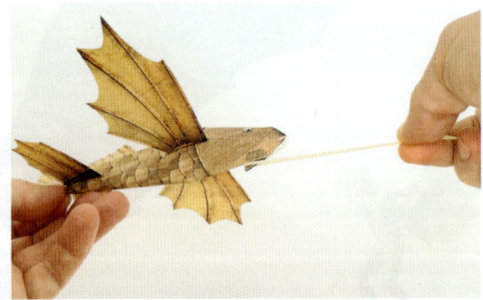

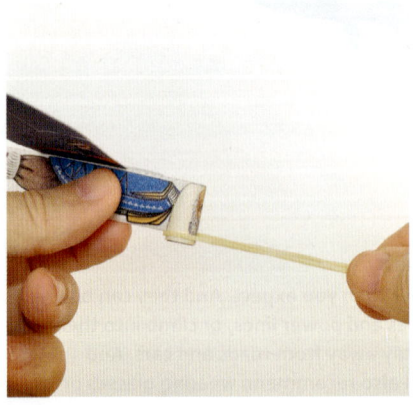

Hook the end of the rubber loop over the hook on the nose of the plane, and hold the plane by the very back of the fuselage. For the first flight, bank the plane about 45 degrees to the side and angle it about 45 degrees from the horizontal. Pull the plane back slightly without twisting, make sure the area is clear, and let go. Work up to big flights slowly. Don't pull too hard until your plane is *trimmed* (adjusted for optimal flights—see pages 28–30 and page 36).

Different planes fly best at different angles. Some are best launched almost straight up. They should rise in a long, loose spiral, and then transition into a gentle glide. Experiment a bit with light pulls to see what works best and gives the greatest climb. Too strong a launch may cause flutter (vibration of the wings), which can hurt the plane. If the plane curves straight into the ground instead of going up, try launching it with the other hand.

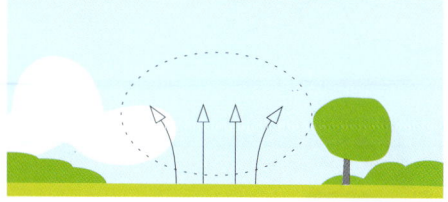

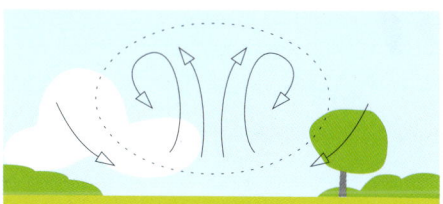

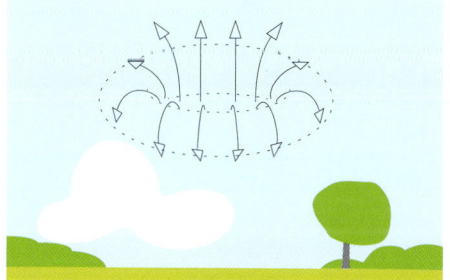

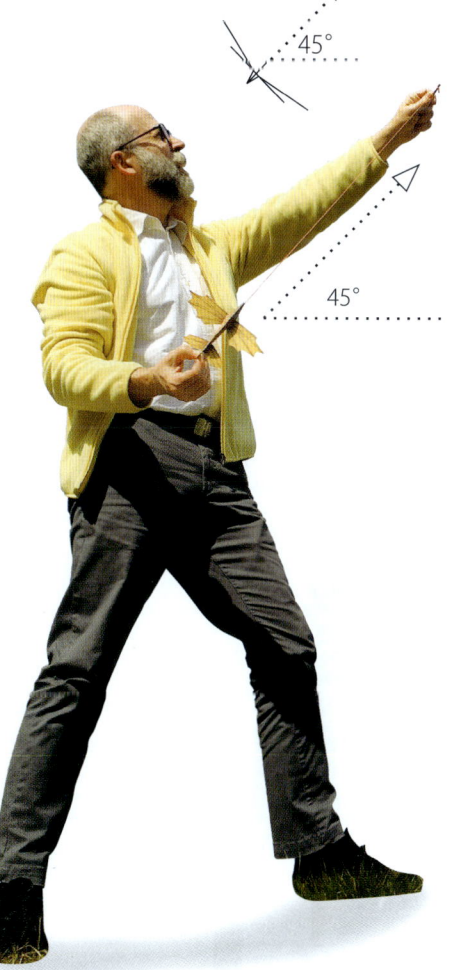

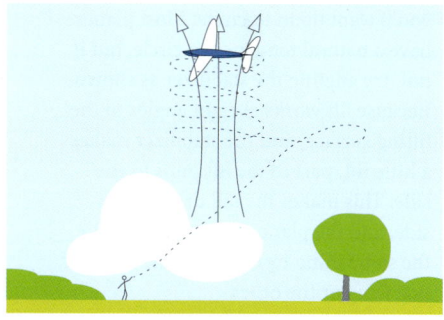

On a calm day, a 30-second flight is pretty good. But on a day with *thermals*, your plane may fly a minute or more, or even go right out of sight. Thermals are big bubbles of rising warm air that form over open areas. If your plane circles inside one that rises faster than the plane sinks, it will climb with the air, like an eagle or sailplane.

Using the Slingshot Launcher 35

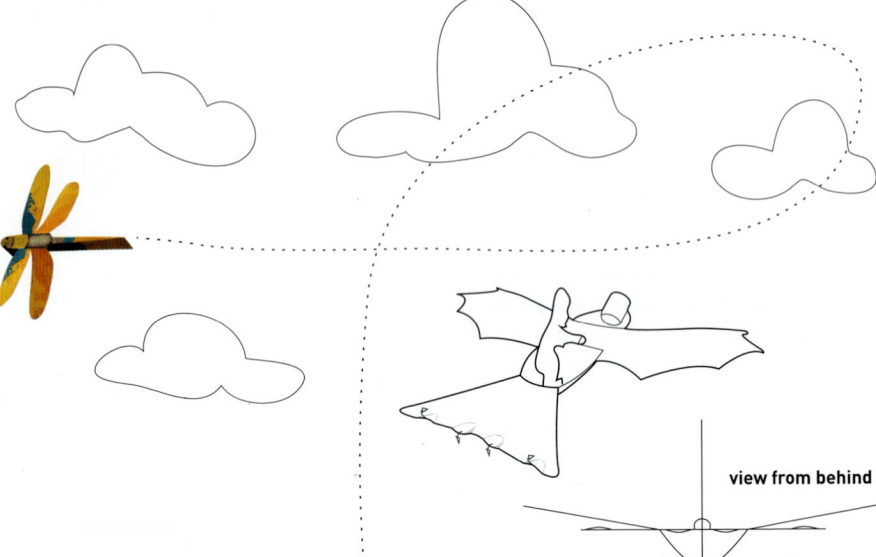

To keep your planes from going too far, you'll want them to circle. Most planes have a natural tendency to circle, but if not, try angling the stabilizer as shown. Because lift works at right angles to the lifting surface, and the stabilizer makes a little lift, part of the lift pulls to the side. This makes the tail drift to that side, and the plane circles. You can do the same thing by changing the angle of one wing or the other.

Most of the planes in this kit fly fine just as built, but to get really long flights, you can turn the inner part of the back edge of the stabilizer down very slightly. This makes the stabilizer act like a small wing, lifting the tail and preventing loops at launch speeds. But to balance that trim, you may need to turn up the outer corners of the stabilizer the same amount. The stabilizer tips will bend and have no effect at high speed, but go back into shape and hold the nose up when the slow glide starts. Add this trim a little at a time to prevent high-speed dives and damage.

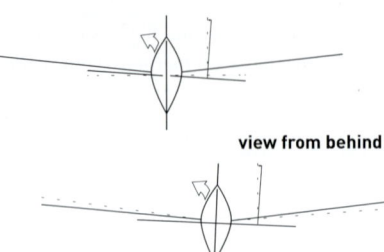

view from behind

36 Leonardo da Vinci's Flying Machines

• praesentium

at vero eos et accusamus et
iusto odio dignissimos ducimus
qui blanditiis praesentium voluptatum
delenit.

• et accusamus et
dignissimos

• ut enim ad minima veniam

• et harum quidem rerum

ut tempor lobortis est, ut pharetra nulla us A
pellentesque rutrum euismod augue ut fringilla B
aliquam posuere blandit lorem vel aliquam C

• vel eum iure

• aliquid ex ea commodi

• ut enim ad minima veniam,
quis nostrum exercitationem ullam

• minima veniam
et harum quidem

37

THE FALLING LEAF

It didn't escape Leonardo's notice that sheets of paper and autumn leaves don't just fall straight down, but flutter back and forth as they drop slowly. What, he wondered, if a person hung beneath a large cloth wing and steered it by shifting their weight? Could it be controlled? Leonardo almost certainly made a model of this idea. The pilot of this little model can't shift his own weight, but he does flutter.

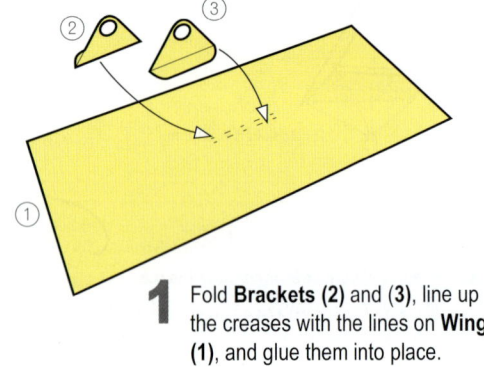

1 Fold **Brackets (2)** and **(3)**, line up the creases with the lines on **Wing (1)**, and glue them into place.

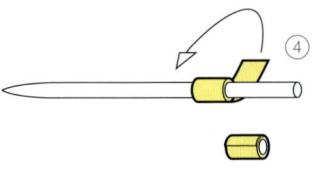

2 Use a round toothpick to roll and glue **Axle Part (4)**. Remove the toothpick.

3 Glue together **Pilot Parts (5)** and **(6)**.

4 Slip the Pilot between the two Brackets. Pass the Axle through all three holes, and glue it into place with small dabs on the outside. Make sure the Pilot can move freely!

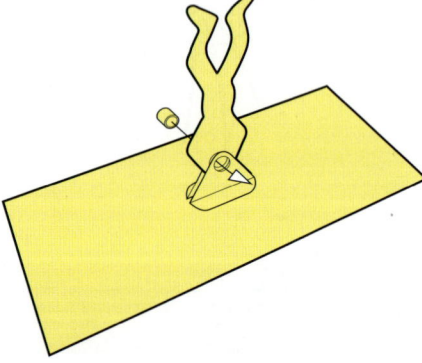

5 All done!

To fly the Falling Leaf, hold it up gently as shown, and drop it.

38 Leonardo da Vinci's Flying Machines

THE FLITTING BIRD

Considering the number of drawings of flying birds that Leonardo drew, and his growing knowledge of the balance needed for flight, it is almost inconceivable that he didn't cut up scraps of paper and fly them, just like this. How far would they go if he flew them on the mountains above Florence? Would they find thermals and join the real birds up among the clouds?

1 Mountain fold the body and tail portion of **Bird (7)**, and valley fold the wings very slightly on the dotted lines.

Here's how it will look when seen from the front.

2 Glue **Ballast (8)** under the head.

3 Glue **Ballast Parts (9) – (16)** under the head.

4 Turn up the wingtips slightly as shown, and you're done.

The Flitting Bird 39

THE PARACHUTE

Leonardo's famous parachute design exists as a single sketch and a short description on a page filled with other ideas. It appears fully formed, as if it could be built and used just as he has drawn it. In fact, several modern parachutists have built and flown replicas! Leonardo had clearly thought a lot about how to build it. But it wasn't until the invention of balloons, two and a half centuries later, that a parachute could be truly tested in flight.

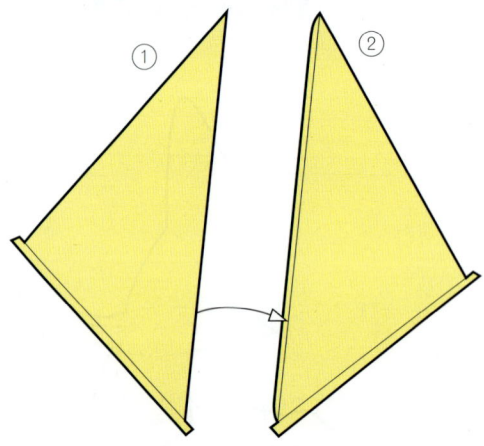

1 Fold the four sides of the parachute canopy. Glue **Side (1)** to the tab on the side of **Side (2)**.

2 Glue the corners together. Make sure they are at a right angle!

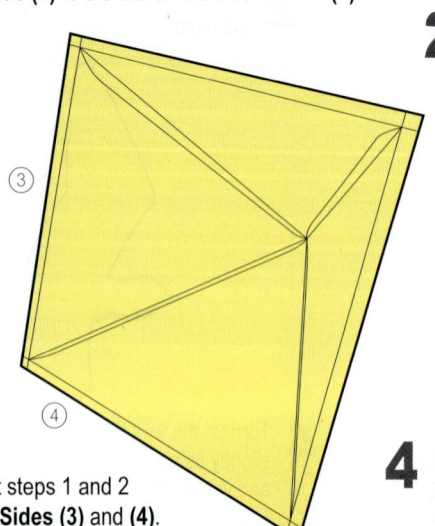

3 Repeat steps 1 and 2 for the **Sides (3)** and **(4)**.

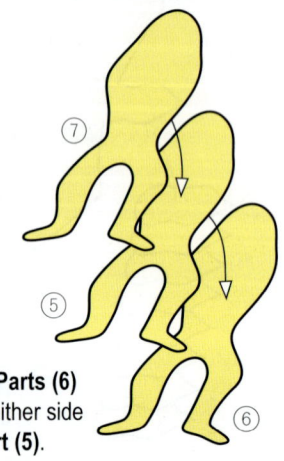

4 Glue **Pilot Parts (6)** and **(7)** to either side of **Pilot Part (5)**.

40 Leonardo da Vinci's Flying Machines

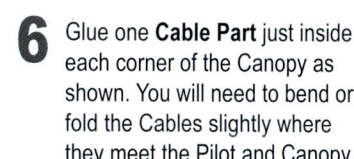

6 Glue one **Cable Part** just inside each corner of the Canopy as shown. You will need to bend or fold the Cables slightly where they meet the Pilot and Canopy.

5 Glue two **Cable Parts** to each side of the Pilot. Use this template to find the right angle.

7 Glue the remaining **Pilot Parts (8)** and **(9)** on either side of the pilot figure. Make sure the illustration is facing out.

The Parachute 41

KITE GLIDER

This is the most glider-like of all of Leonardo's designs, and the most practicable. So when people build flying reproductions of Leonardo's flying machines, this is the one most of them build. But it isn't clear from his drawing which end faces front. In terms of aerodynamic balance, the pointy end probably should go first, but most builders are hang glider pilots, and think the pointy end looks more natural at the back. I built and tested this glider both ways, and there wasn't any really big difference. But I don't want anybody getting poked in the eye, so here we are, pointy end at the back.

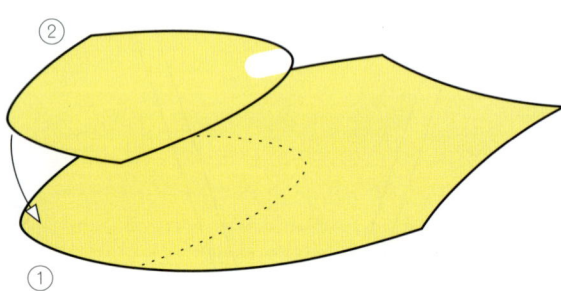

1 Start with the bottom of **Wing (1)** facing up. All of these drawings show the glider from below. Glue the large **Wing Reinforcement (2)** to the bottom of **Wing (1)**, flush with the front edge.

2 Glue the small **Reinforcement Parts (3) – (9)** to the bottom of **Wing Reinforcement Part (2)**, flush with the front edge.

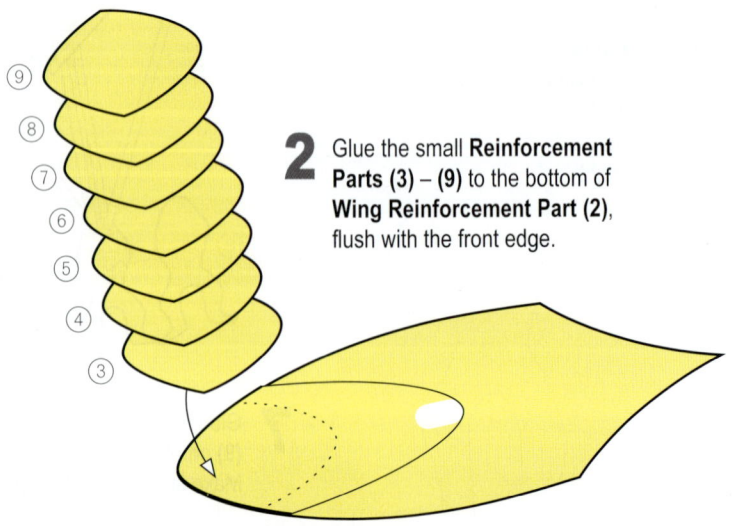

42 Leonardo da Vinci's Flying Machines

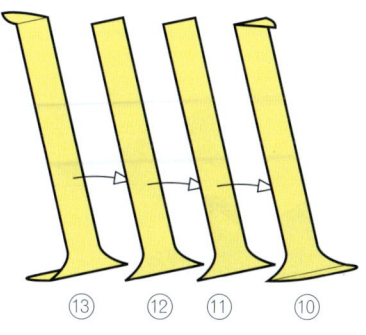

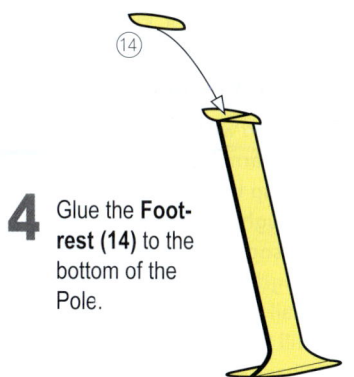

3 Fold the **Pole Parts (10)** and **(13)**, and glue them together with **Pole Parts (11)** and **(12)** sandwiched in between.

4 Glue the **Footrest (14)** to the bottom of the Pole.

5 Mountain fold the small tab on **Pilot Part (15)**. Glue the tab to the inside of the Footrest, just touching the Pole, and glue the hand to the Pole as shown.

6 Glue the other **Pilot Part (16)** to the Pole and Pilot in the same way, but leave the legs separate.

Here's how it looks when seen from the front.

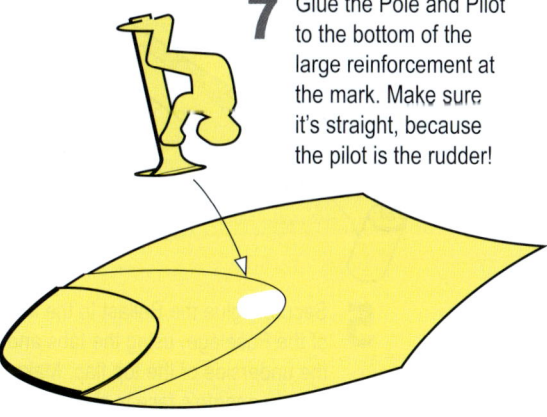

7 Glue the Pole and Pilot to the bottom of the large reinforcement at the mark. Make sure it's straight, because the pilot is the rudder!

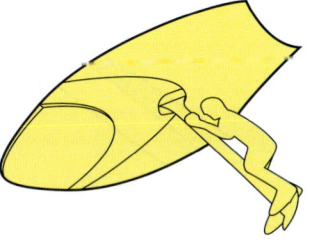

8 Turn up the point at the back slightly for stability, and you're done!

Kite Glider

FLYING LEONARDO

One of Leonardo's small sketches shows a tiny man with wings strapped to his arms, stretched out as if to grasp the sky. Leonardo may have thought this practical at one point, but he soon realized he hadn't enough strength to get off the ground. There is no tail in the sketch, and in fact this plane will fly without the tail, if you turn up the back edges of the wing a bit. The tail makes it easier to launch. You can also hook the rubber catapult under the chin and fly it high and far.

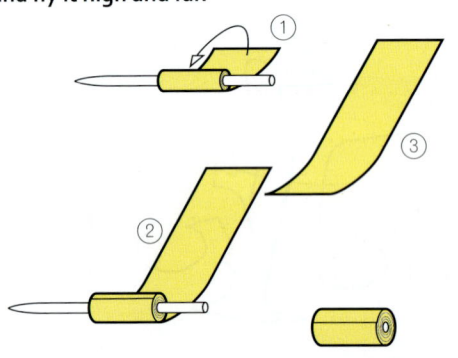

1 Use a round toothpick to roll **Ballast Part (1)**. Fasten the end with a tiny bit of glue. Then attach **Ballast Part (2)** and roll and glue it the same way, followed by **Ballast Part (3)**. Make sure Leonardo's face shows on the outside! Remove the toothpick.

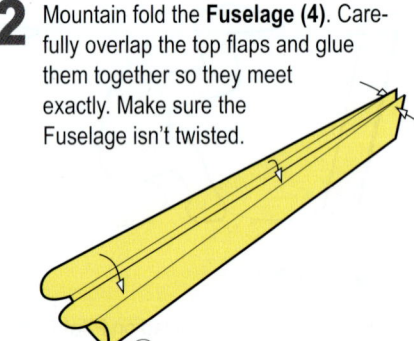

2 Mountain fold the **Fuselage (4)**. Carefully overlap the top flaps and glue them together so they meet exactly. Make sure the Fuselage isn't twisted.

3 Seal the back of the Fuselage with a tiny bit of glue.

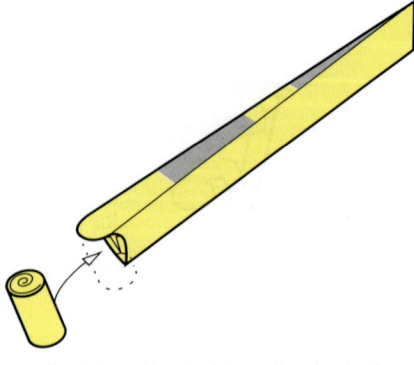

4 Fold **Reinforcement (5)** and glue it inside the front of the Fuselage, flush with the front edge.

5 Securely glue the Ballast to the front of the Fuselage, using the tabs and the underside of the top flap. Make sure Leonardo's face is showing!

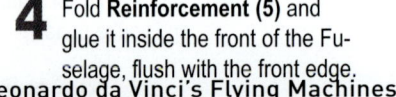

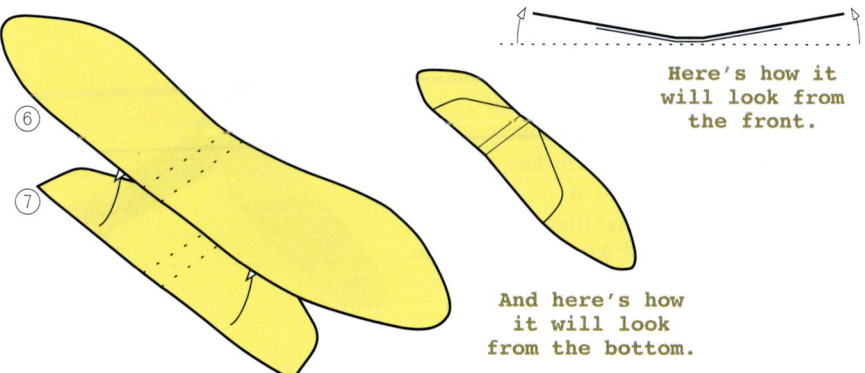

Here's how it will look from the front.

And here's how it will look from the bottom.

6 Lightly fold **Wing Parts (6)** and **(7)**, and glue **Reinforcement (7)** to the underside of **Wing (6)** so that the arms on part (7) show.

7 Glue the Wing to the top of the Fuselage over the gray area.

8 Glue the **Tail (8)** to the top of the Fuselage over the gray area.

9 All done!

Flying Leonardo 45

LEONARDO'S DRAGONFLY

It isn't hard to imagine Leonardo lying on his back in the grass beside a brook in late summer, watching the dragonflies flitting about overhead, and wishing he could fly like them. He left several sketches of dragonflies, and he knew that they flapped their front and back wings in alternation. In fact, one of his earliest designs for a flying machine uses dragonfly-style wings powered by a person pedaling from below. He may have made a model like the one here, cut out of one of his own sketches. This little glider swoops rather than flits, but you'll be amazed at how well it flies.

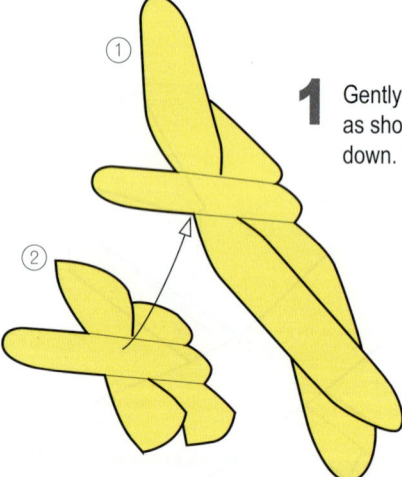

1 Gently crease the **Wings (1)** and the **Reinforcement (2)** as shown. The front wings go up, and the back wings go down. Glue the Reinforcement to the bottom of the Wings.

```
Here's how the wings will
     look from the front.
```

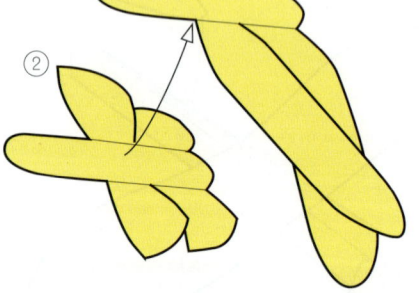

2 Mountain fold the **Fuselage (3)**. Carefully overlap the top flaps and glue them together so they meet exactly. Make sure the Fuselage isn't twisted.

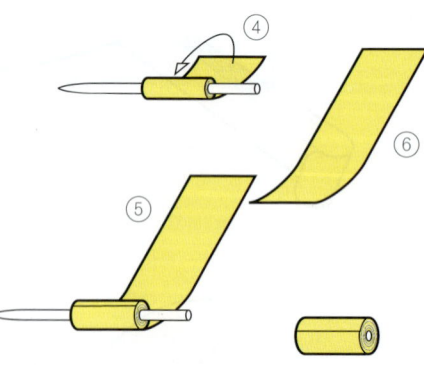

3 Seal the back of the Fuselage with a tiny bit of glue.

4 Use a round toothpick to roll **Ballast Part (4)**. Fasten the end with a tiny bit of glue. Then attach **Ballast Part (5)** and roll and glue it the same way, followed by **Ballast Part (6)**. Remove the toothpick.

46 Leonardo da Vinci's Flying Machines

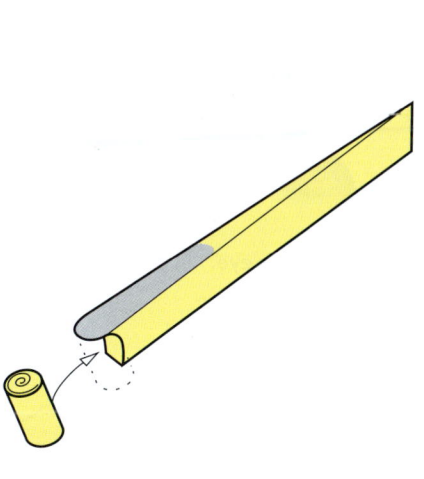

5 Securely glue the Ballast to the front of the Fuselage, using the raw edges of the sides and the underside of the top flap.

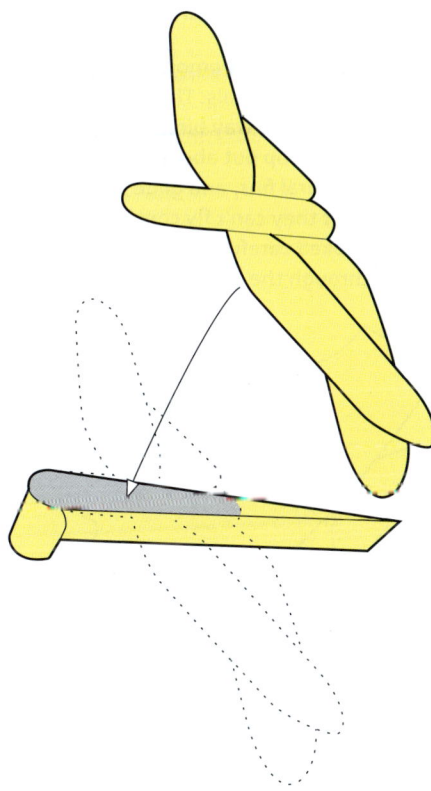

6 Glue the Wing to the top of the Fuselage as shown.

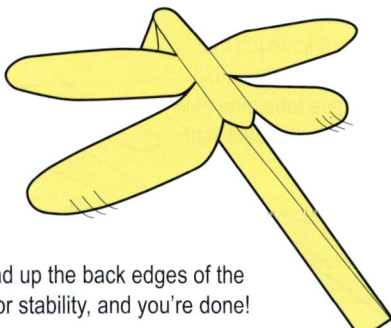

7 Carefully bend up the back edges of the back wings for stability, and you're done!

Leonardo's Dragonfly 47

LEONARDO'S FLYING FISH

The flying fish is a rarity among Leonardo's many sketches of flying animals. That's because flying fish don't actually fly the way birds and bats do. They speed up under water, pop out above the waves, spread their long pectoral fins, and glide smoothly across the water. But they can't fly continuously. Still, Leonardo looked carefully at everything that was capable of sailing through the air, and the flying fish didn't fail to catch his eye.

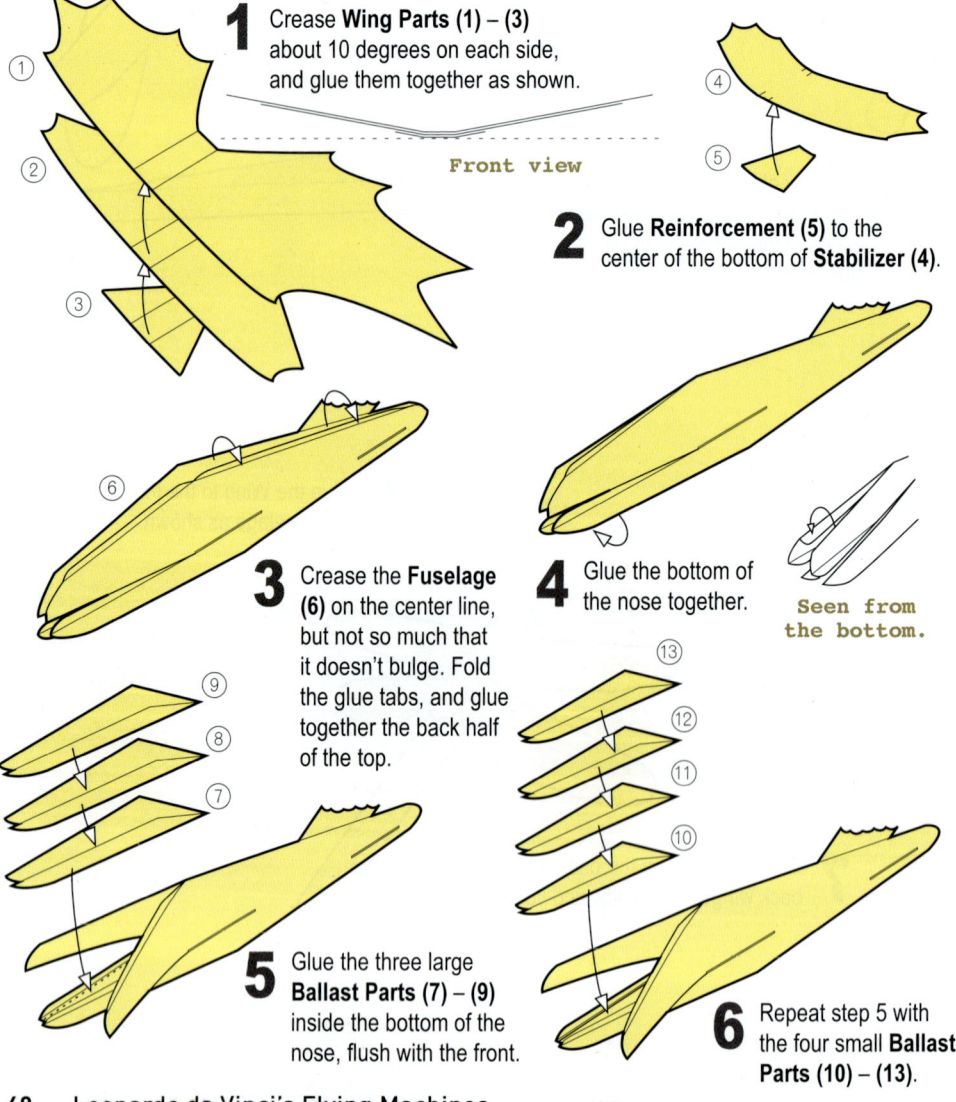

1 Crease **Wing Parts (1) – (3)** about 10 degrees on each side, and glue them together as shown.

Front view

2 Glue **Reinforcement (5)** to the center of the bottom of **Stabilizer (4)**.

3 Crease the **Fuselage (6)** on the center line, but not so much that it doesn't bulge. Fold the glue tabs, and glue together the back half of the top.

4 Glue the bottom of the nose together.

Seen from the bottom.

5 Glue the three large **Ballast Parts (7) – (9)** inside the bottom of the nose, flush with the front.

6 Repeat step 5 with the four small **Ballast Parts (10) – (13)**.

48 Leonardo da Vinci's Flying Machines

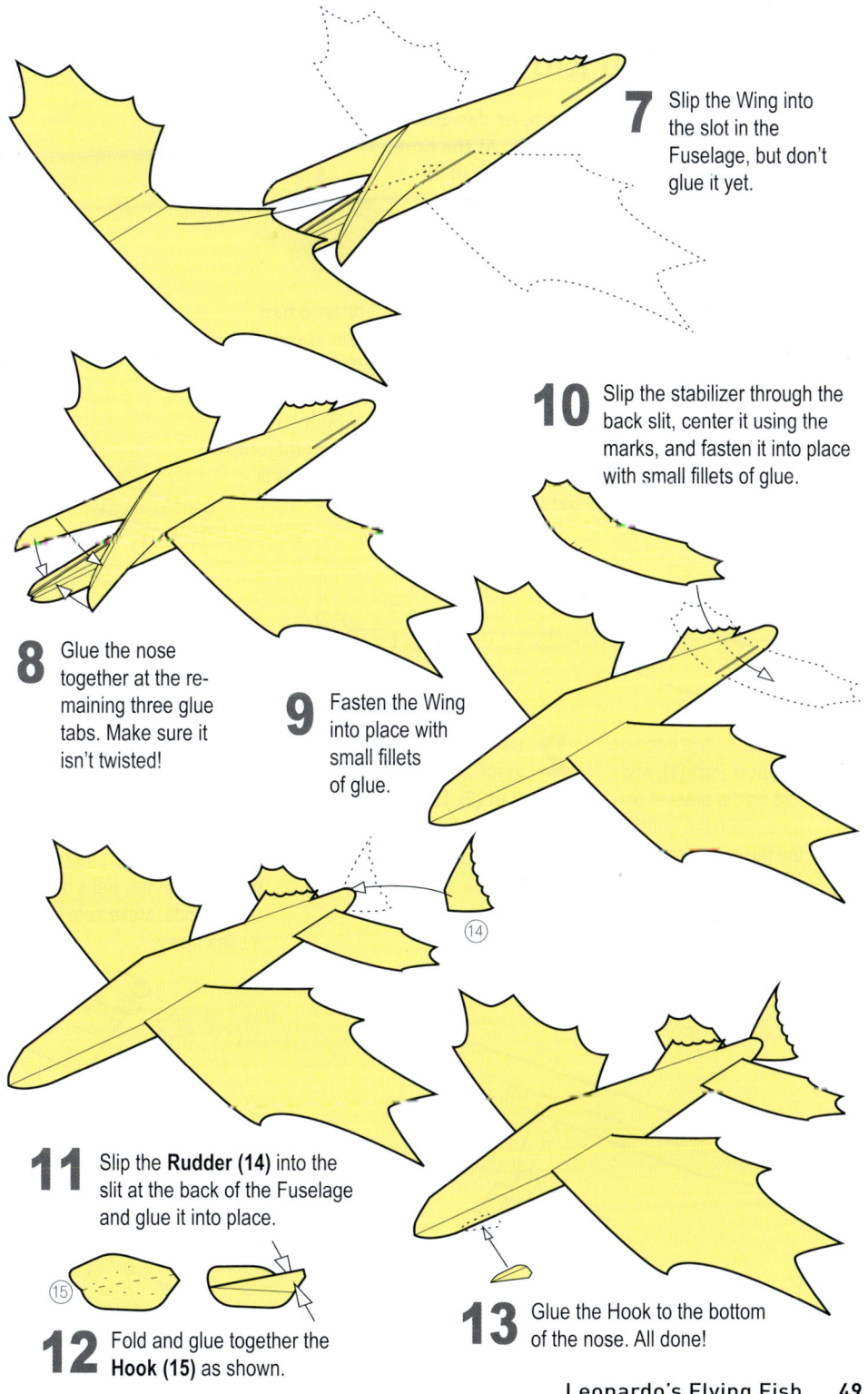

Leonardo's Flying Fish 49

WING-TESTING RIG

Quite early in Leonardo's research, he designed this device to test the effectiveness of his wings. At the time, he still thought that birds and bats created lift by pushing air down with their wings. This machine had a large wing attached to an articulated lever. A very energetic person was to push down firmly on the lever, which would then push down the wing. Leonardo had attached a 200-pound weight to the bottom of the front stand. If the wing created enough lift to make the stand pop up off the ground, he thought, it would be good enough to lift a man. Did he ever build this machine? No one knows, but I think he very likely built a model. Like this paper version, his model would have made the stand jump up and down a bit, but he would have learned from it that this is definitely not how birds and bats generate lift!

1 Fold in the two ends of **Support Part (1)**, and fold up the bracket portions. Glue the ends to the base, but leave the brackets free.

2 Use a round toothpick to roll and glue **Axle Part (2)**. Remove the toothpick.

3 Mountain fold **Lever Part (3)** as shown. Slip it between the brackets of **Support Part (1)**, carefully pass **Axle Part (2)** through the holes, and fasten the Axle with tiny dabs of glue on the ends. Make sure it moves freely.

Here's how it will look from the front.

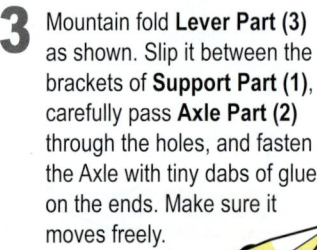

Here's how it will look.

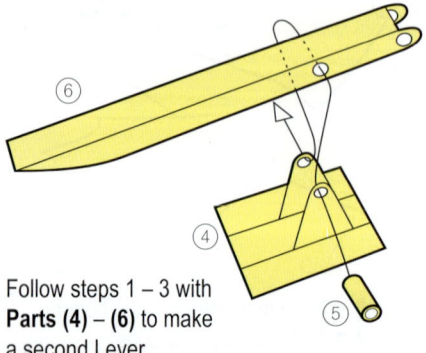

4 Follow steps 1 – 3 with **Parts (4) – (6)** to make a second Lever.

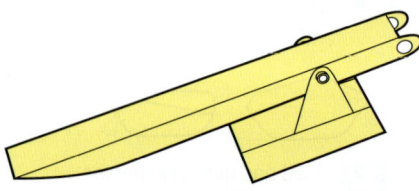

Here's how it will look.

50 Leonardo da Vinci's Flying Machines

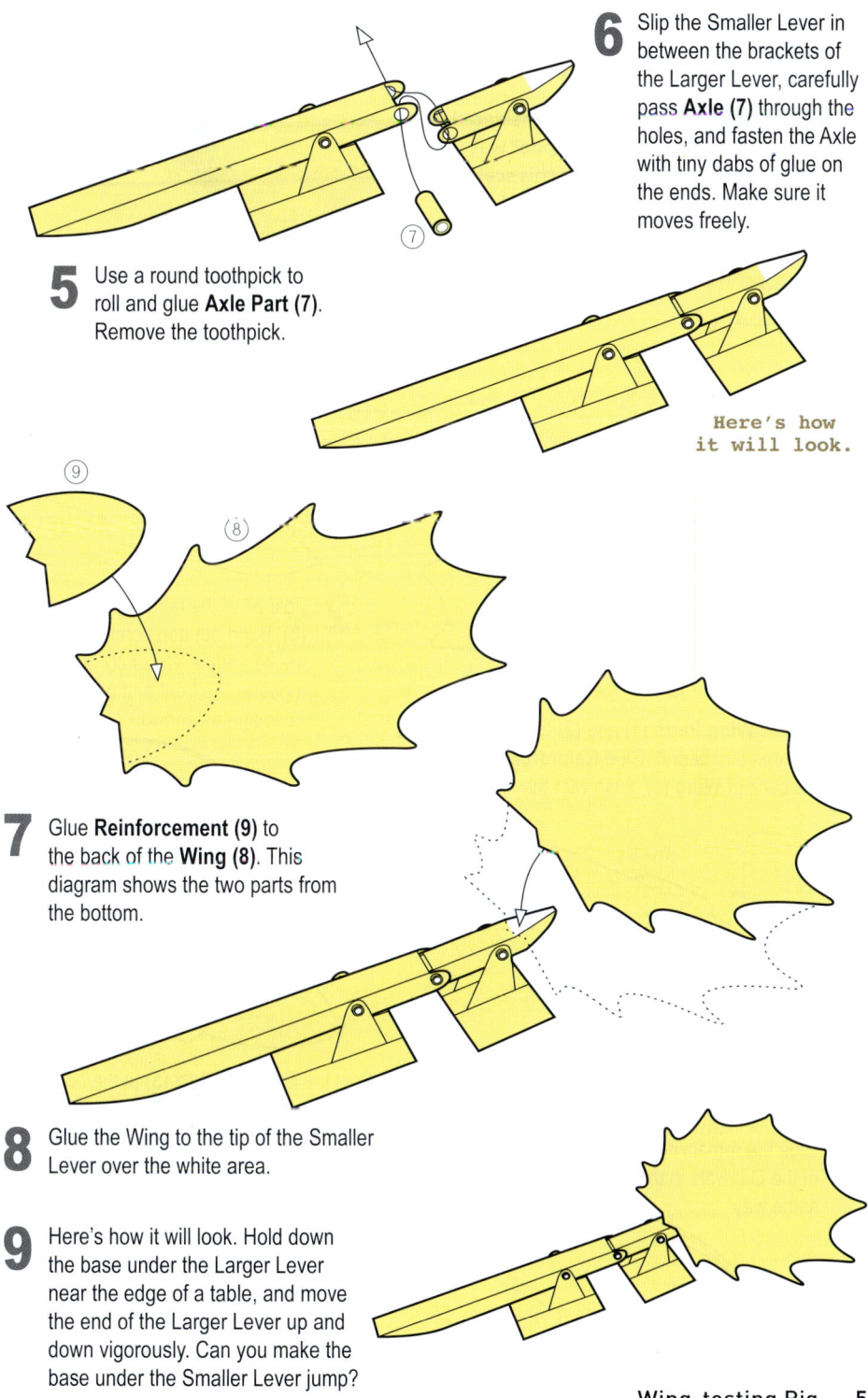

5 Use a round toothpick to roll and glue **Axle Part (7)**. Remove the toothpick.

6 Slip the Smaller Lever in between the brackets of the Larger Lever, carefully pass **Axle (7)** through the holes, and fasten the Axle with tiny dabs of glue on the ends. Make sure it moves freely.

Here's how it will look.

7 Glue **Reinforcement (9)** to the back of the **Wing (8)**. This diagram shows the two parts from the bottom.

8 Glue the Wing to the tip of the Smaller Lever over the white area.

9 Here's how it will look. Hold down the base under the Larger Lever near the edge of a table, and move the end of the Larger Lever up and down vigorously. Can you make the base under the Smaller Lever jump?

Wing-testing Rig 51

LEONARDO'S FLYING BOAT

One of the mechanisms Leonardo considered for increasing the efficiency of the pilot was a double screw turned by a lever. At this scale, I just gave Leonardo a lever to hold, and you can imagine the rest. In this plane, Leonardo himself is the rudder, so be sure he is straight!

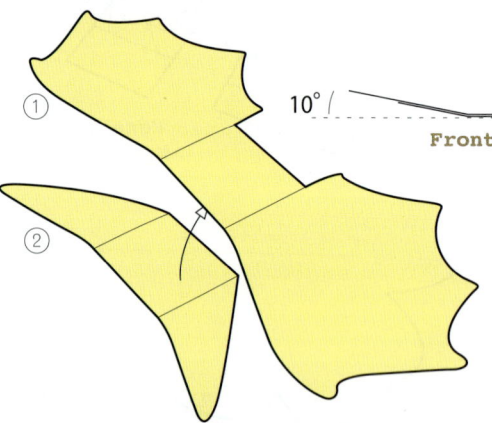

1 Crease **Wing Parts (1)** and **(2)** to create about 10 degrees of dihedral. Glue **Reinforcement (2)** to the back of **Wing (1)**, flush with the leading edge.

2 Fold all of the tabs on **Fuselage (3)**. Bend but don't crease along the centerline. Carefully glue together the front and back of the Fuselage as shown.

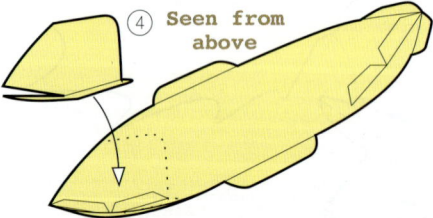

3 Fold **Nose Reinforcement (4)**, and glue it inside the nose so that the front points meet at the pointed tip of the Fuselage.

4 Fold the **Gunwale Part (5)** at the center. Carefully center it on the outside front tip of the Fuselage, and glue the left half on, flush with the edge of the boat.

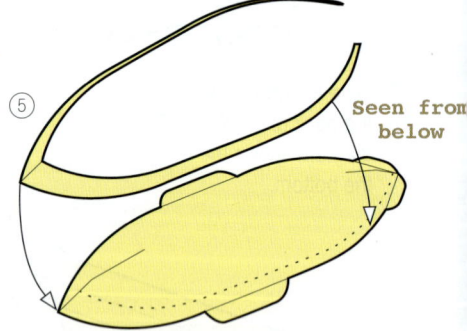

5 Glue the remaining half of the Gunwale in the same way.

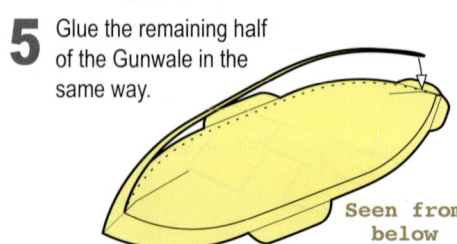

6 Here's how it will look from the bottom.

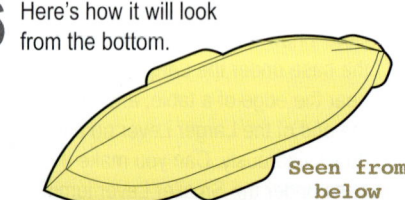

52 Leonardo da Vinci's Flying Machines

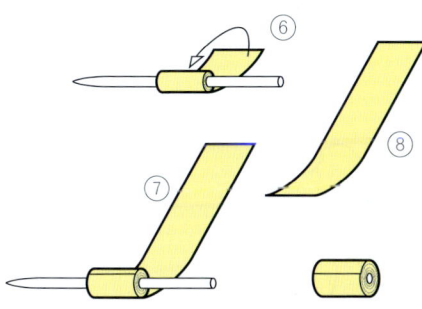
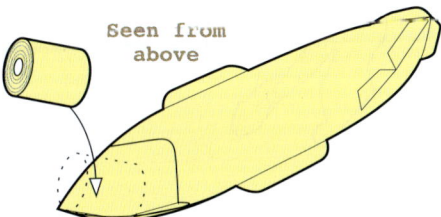

7 Use a round toothpick to roll **Ballast Part (6)**. Fasten the end with a tiny bit of glue. Then, attach **Ballast Part (7)** and roll and glue it the same way, followed by **Ballast Part (8)**. Remove the toothpick.

8 Glue the Ballast Roll firmly inside the front of the boat, flush with the tip of the Fuselage.

9 Glue the Wing to the Fuselage. The creases on the Wing should exactly match the folds on the glue tabs.

10 Glue the **Stabilizer (9)** to the tabs at the rear of the Fuselage. The Stabilizer should be flat, and the front corners should just meet the front corners of the tabs.

Leonardo's Flying Boat

11 Fold the glue tabs on **Leonardo (10)**. Fold over the top of the lever, and glue it.

12 Glue Leonardo to the inside rear of the Fuselage and the top of the wing. Use the dot on the wing and the seam on the Fuselage bottom to line him up. Make sure he's straight!

13 Fold and glue the **Hook (11)**.

14 Glue the Hook to the bottom of the nose as shown. The back of the Hook should meet the corner in the nose seam. All done!

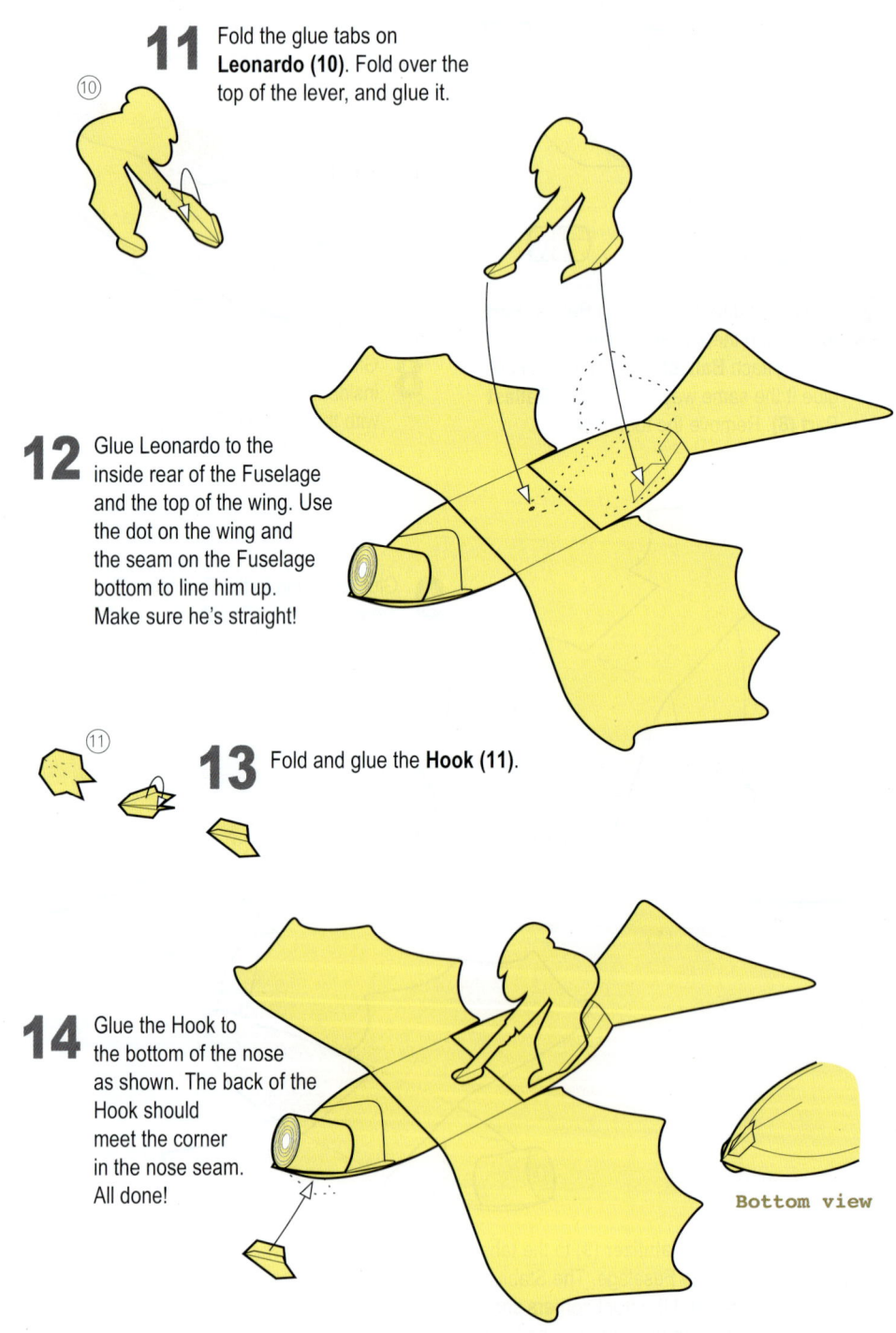

Bottom view

54 Leonardo da Vinci's Flying Machines

THE ORNITHOPTER BOAT

Leonardo may not have been specifically thinking of boats when he was designing his ornithopters. Most of these designs also look like birds with the top half of the body removed to make room for the pilot. But in the end, the construction and shape are very little different from the small boats he would have known, so it is easiest to think of them that way. This one envisions the pilot pumping a big lever up and down to make the wings flap, something no one would actually have the strength to do. The shape of the wing comes straight from one of Leonardo's sketches.

1 Fold all of the tabs on **Fuselage (1)**. Bend but don't crease it along the centerline. Carefully glue together the front and back of the Fuselage as shown.

2 Carefully push the two seams closed with your fingers and fasten them with a bit of glue on the inside.

3 Fold **Nose Reinforcement (2)**, and glue it inside the nose so that the front points meet at the pointed tip of the Fuselage.

4 Fold the **Gunwale Part (3)** at the center. Fold the other tabs too. Carefully center it on the outside front tip of the Fuselage, and glue the left half on, flush with the edge of the boat.

5 Glue on the remaining half of the Gunwale in the same way.

6 Here's how it will look from the bottom.

7 Use a round toothpick to roll **Ballast Part (4)**. Fasten the end with a tiny bit of glue. Then attach **Ballast Part (5)** and roll and glue it the same way, followed by **Ballast Part (6)**. Remove the toothpick.

The Ornithopter Boat 55

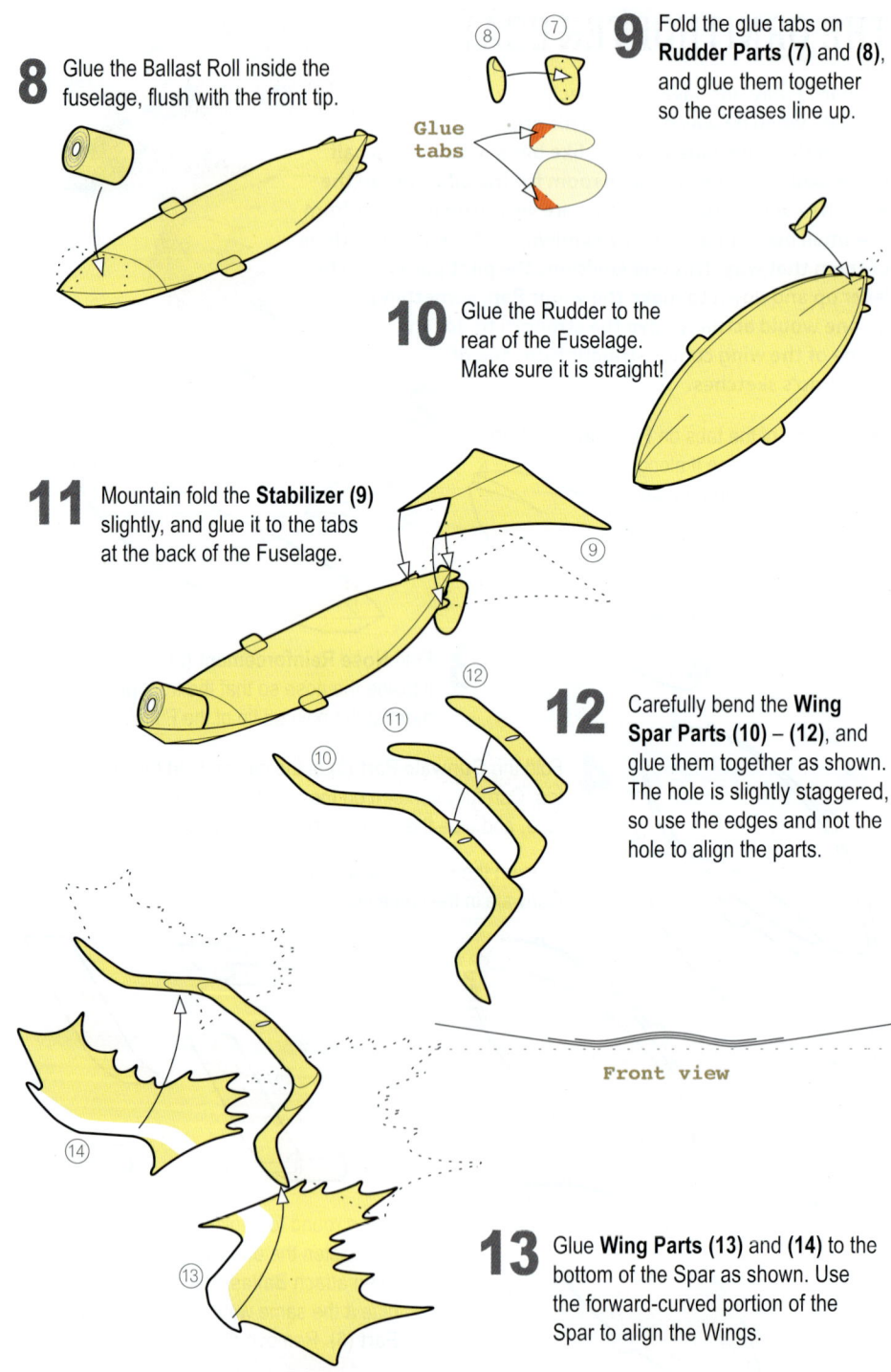

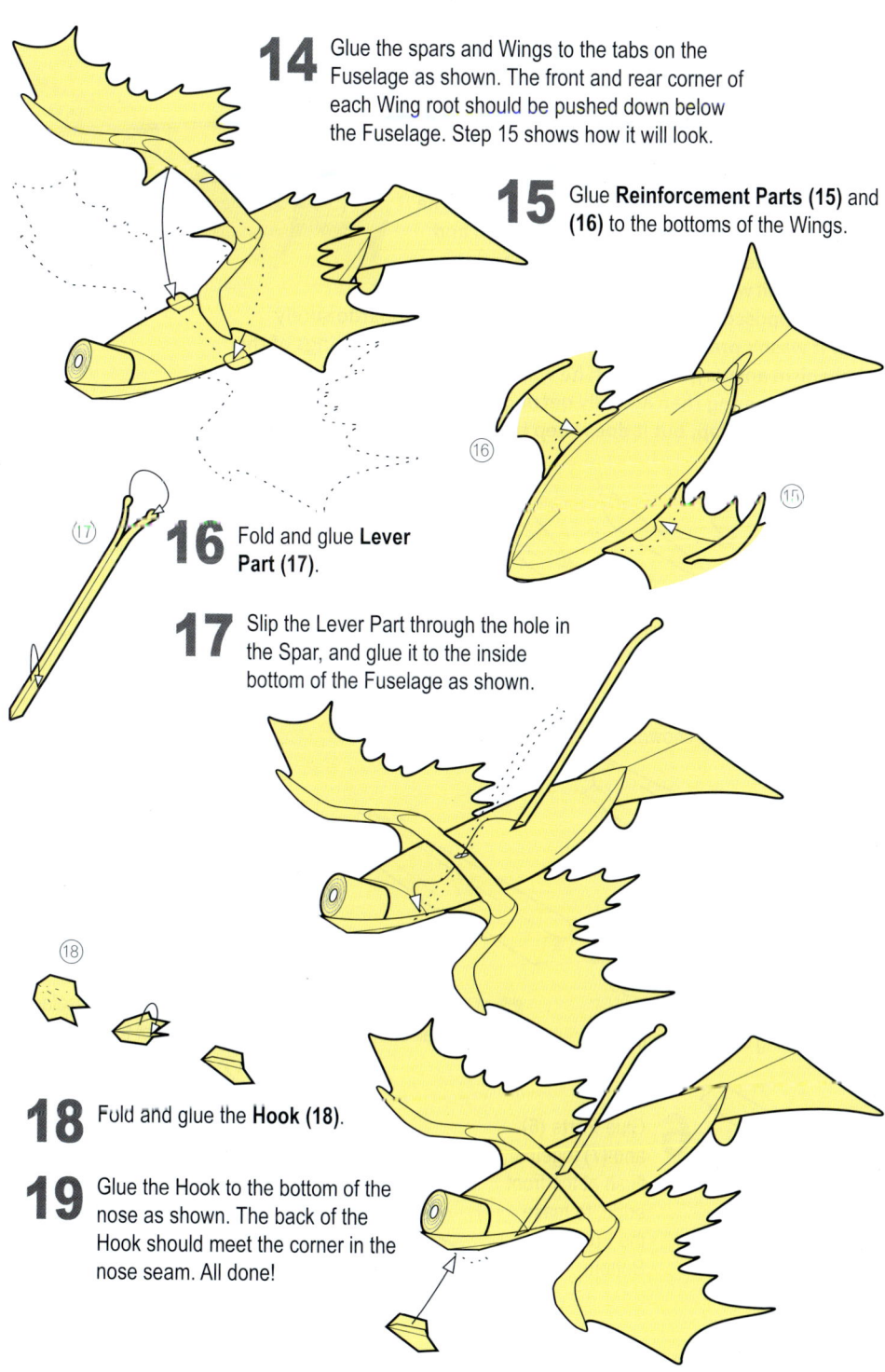

14 Glue the spars and Wings to the tabs on the Fuselage as shown. The front and rear corner of each Wing root should be pushed down below the Fuselage. Step 15 shows how it will look.

15 Glue **Reinforcement Parts (15)** and **(16)** to the bottoms of the Wings.

16 Fold and glue **Lever Part (17)**.

17 Slip the Lever Part through the hole in the Spar, and glue it to the inside bottom of the Fuselage as shown.

18 Fold and glue the **Hook (18)**.

19 Glue the Hook to the bottom of the nose as shown. The back of the Hook should meet the corner in the nose seam. All done!

The Ornithopter Boat

THE PRONE ORNITHOPTER

One of Leonardo's best known flying machines is the pedal-powered ornithopter. The drawings show it without cloth on the wings, so you can see how the pedals and ropes move the joints and flap the wings. The pilot was to lie prone on a board and push on the pedals like climbing stairs, and the cruciform tail was attached by a pole to his head. How he was supposed to take off and land isn't clear. Leonardo surely knew it wasn't practical, but he made many detailed drawings of the mechanism anyway, as though he was more interested in showing off his engineering than actually getting it into the air. This paper version doesn't flap, but it does keep the pilot aloft.

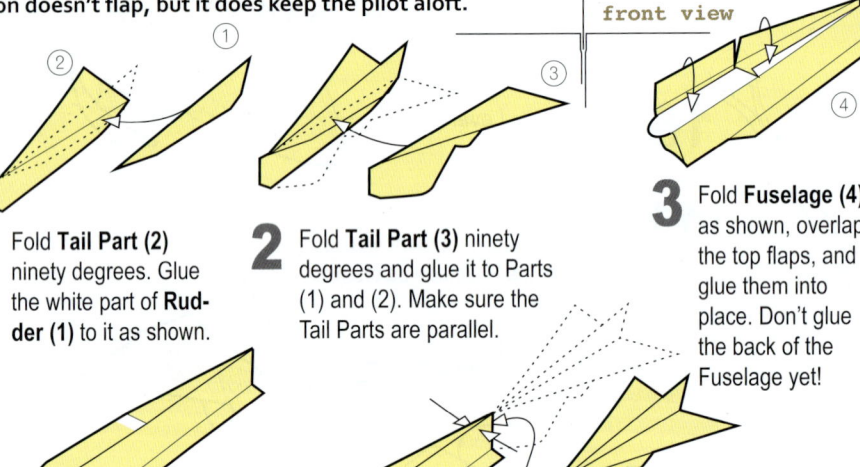

1 Fold **Tail Part (2)** ninety degrees. Glue the white part of **Rudder (1)** to it as shown.

2 Fold **Tail Part (3)** ninety degrees and glue it to Parts (1) and (2). Make sure the Tail Parts are parallel.

3 Fold **Fuselage (4)** as shown, overlap the top flaps, and glue them into place. Don't glue the back of the Fuselage yet!

4 Fold **Reinforcement (5)** and glue it inside the Fuselage, with the creases just matching the front edge.

5 Glue the Tail Assembly inside the back of the Fuselage. The Tail should be parallel with the top of the Fuselage.

6 Glue **Parts (6)** and **(7)** together, flush at the front edge, to make the Fuselage Bottom.

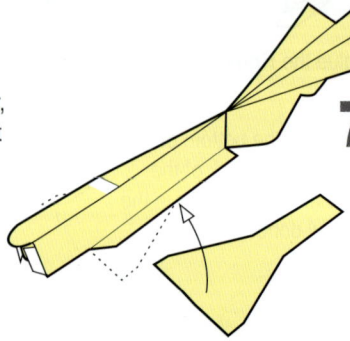

7 Glue the Fuselage Bottom to the glue tabs on the Fuselage.

58 Leonardo da Vinci's Flying Machines

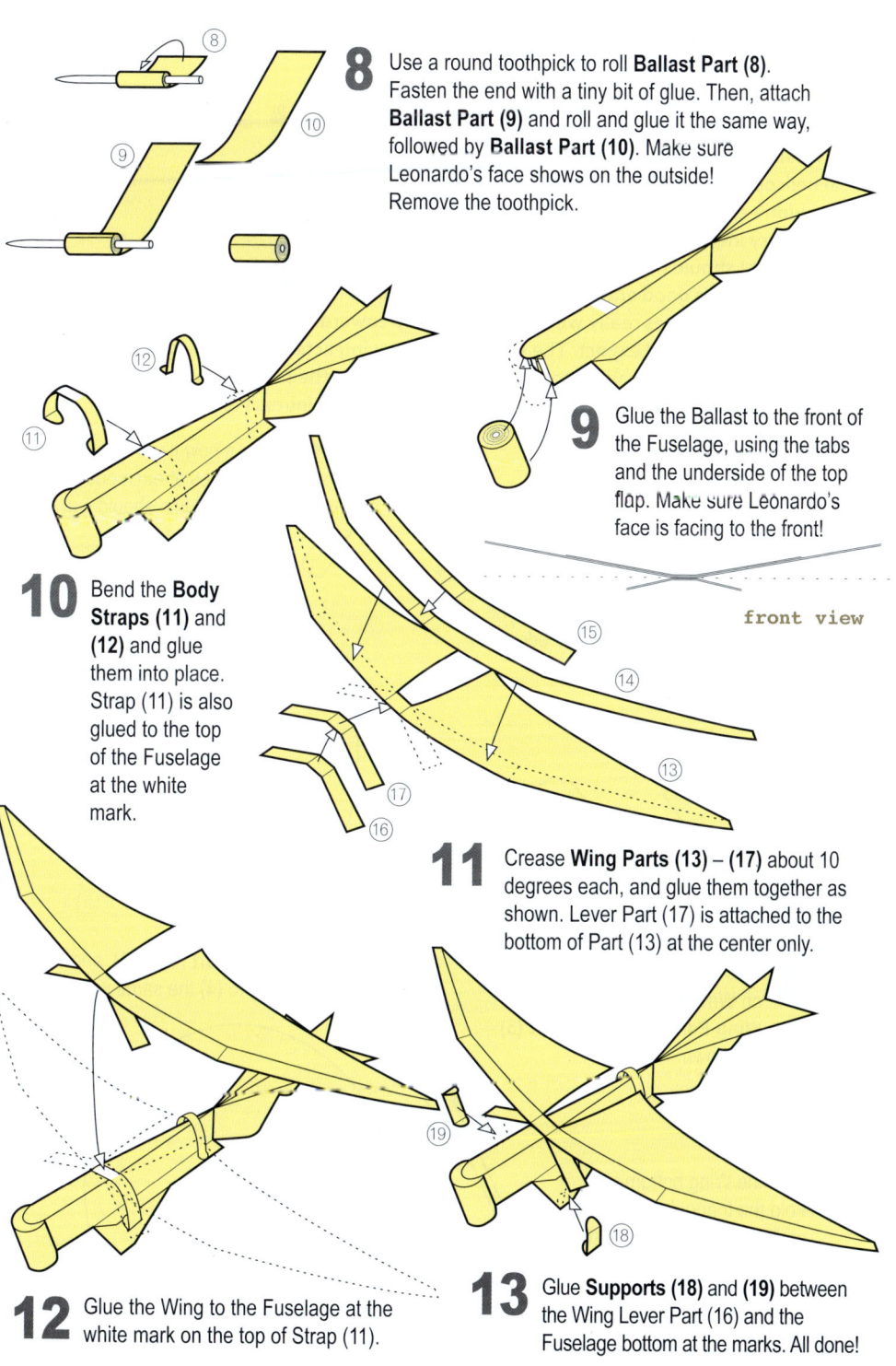

8 Use a round toothpick to roll **Ballast Part (8)**. Fasten the end with a tiny bit of glue. Then, attach **Ballast Part (9)** and roll and glue it the same way, followed by **Ballast Part (10)**. Make sure Leonardo's face shows on the outside! Remove the toothpick.

9 Glue the Ballast to the front of the Fuselage, using the tabs and the underside of the top flap. Make sure Leonardo's face is facing to the front!

front view

10 Bend the **Body Straps (11)** and **(12)** and glue them into place. Strap (11) is also glued to the top of the Fuselage at the white mark.

11 Crease **Wing Parts (13) – (17)** about 10 degrees each, and glue them together as shown. Lever Part (17) is attached to the bottom of Part (13) at the center only.

12 Glue the Wing to the Fuselage at the white mark on the top of Strap (11).

13 Glue **Supports (18)** and **(19)** between the Wing Lever Part (16) and the Fuselage bottom at the marks. All done!

The Prone Ornithopter

THE FLYING SCREW

Like so many other people over the years, I just assumed that Leonardo's helical helicopter couldn't actually fly. The wing wouldn't create lift so much as just push air down, which is a very inefficient way to get off the ground. But then I thought I should at least give it a try. Using a string to spin it like a top is good enough to get it going. It sort of flies, but I can't say it flies really well. It won't pop up toward the ceiling, the way you'd expect. The heavy whirling wing acts like a gyroscope as well as a propeller, and gyroscopes want to move perpendicular to their axis of rotation. In other words, this screw flies sideways, and at great speed. So give yourself lots of room!

2 Here's how it will look. The two circles at each end of the dotted line should just touch the seam.

1 Wrap the **Core Part (1)** tightly around a pencil, and glue the outside edge into place. Remove the pencil.

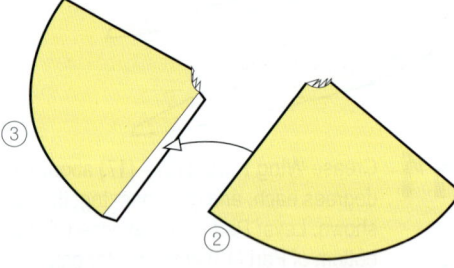

3 Fold up the triangular glue tabs on **Wing Parts (2) – (5)**. Glue **Wing Part (2)** to **Wing Part (3)** as shown.

4 Glue **Wing Part (4)** to (3), and **Wing Parts (5)** to (4) the same way.

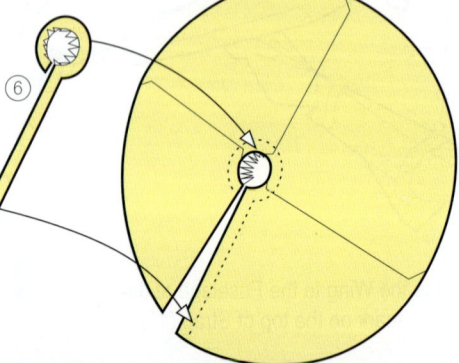

5 Turn the Wing bottom up. Fold the triangular glue tabs on **Reinforcement Part (6)**, and glue it to the Wing as shown.

60 Leonardo da Vinci's Flying Machines

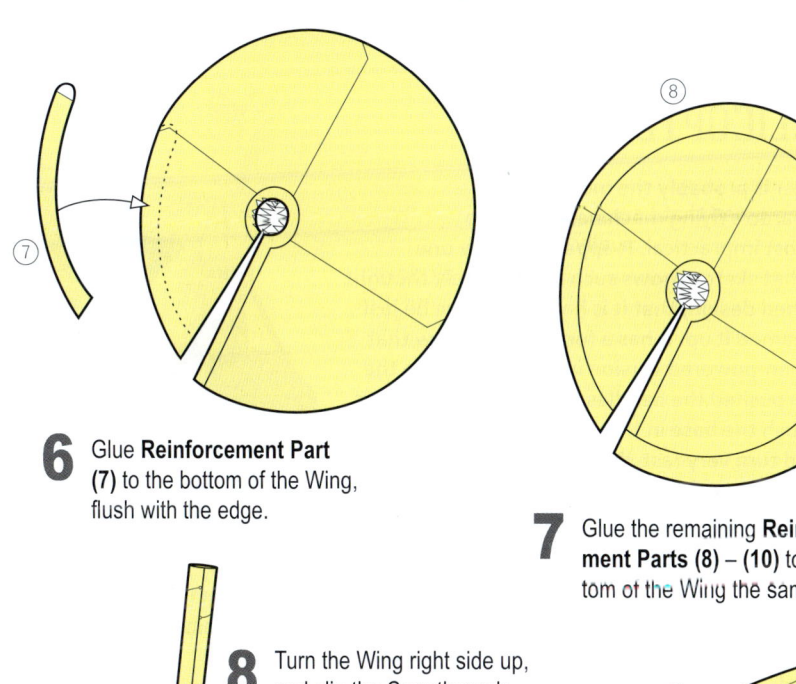

6 Glue **Reinforcement Part (7)** to the bottom of the Wing, flush with the edge.

7 Glue the remaining **Reinforcement Parts (8) – (10)** to the bottom of the Wing the same way.

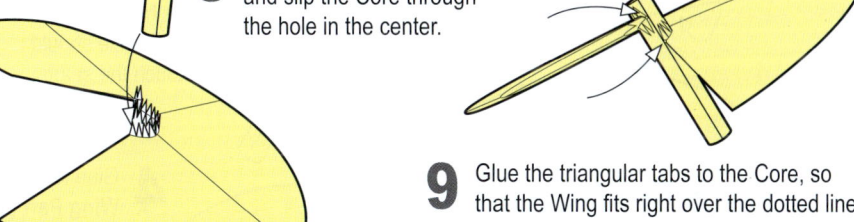

8 Turn the Wing right side up, and slip the Core through the hole in the center.

9 Glue the triangular tabs to the Core, so that the Wing fits right over the dotted line. The edges of the Wing should just touch the circles at each end of the dotted line. See the bottom of page 27 for tips.

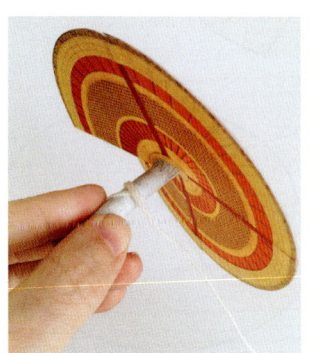
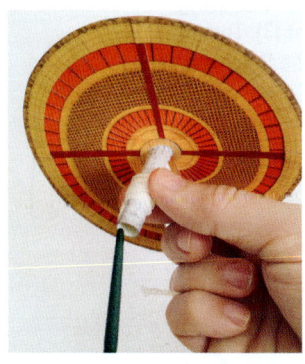
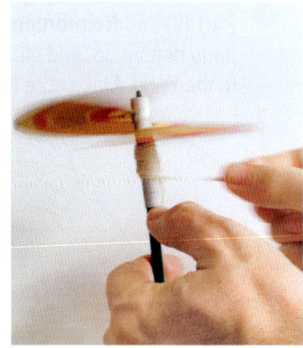

Use about two feet of string or heavy thread to spin the screw. Hold the tip and carefully wind the string counter-clockwise.

Keep the string tight while you slip the screw onto the tip of a chopstick or similar item. Rest it on your thumbnail to keep it from slipping down too far.

Pull the string steadily and without jerking. Accelerate slowly and pull the string right to the end. The screw will fly off sideways.

The Flying Screw

THE HELICOPTER

This helicopter is probably the most famous of all of Leonardo's flying machines—but also one of the most impractical. It appears in only one sketch, but that sketch shows such a completely thought out and finished design, that it is hard to believe he just suddenly dreamed it up. It has a fundamental flaw that makes a human-powered version impossible. When the pilot or pilots pushed the handles to turn the wing, their feet would push the base in the other direction, so that neither would turn very fast. With more power, it might rotate fast enough to fly. Some people think Leonardo may have made a spring-powered model, and if he did, it might have hopped about a bit. This model won't hop or fly, I'm afraid, but what it will do is look very nice on your desk!

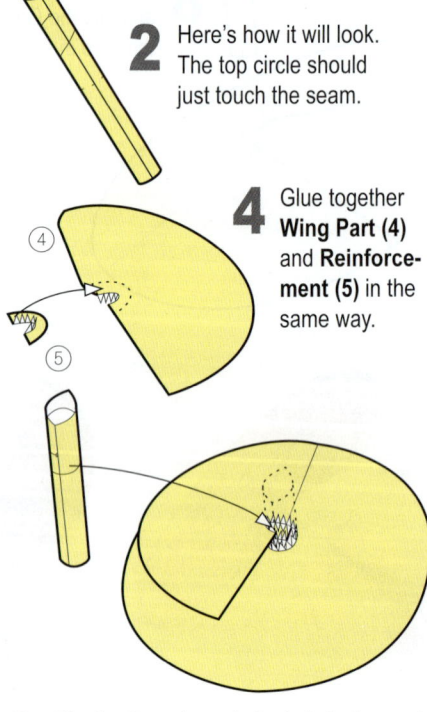

1 Wrap the **Core Part (1)** tightly around a pencil, and glue the outside edge into place. Remove the pencil.

2 Here's how it will look. The top circle should just touch the seam.

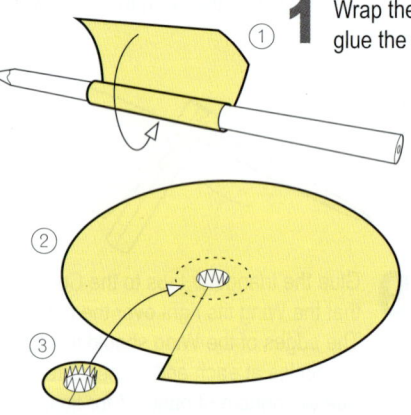

3 Fold up the triangular glue tabs on **Wing Part (2)** and **Reinforcement (3)**. Turn both parts bottom up, and glue the Reinforcement to the Wing. Make sure the openings line up.

4 Glue together **Wing Part (4)** and **Reinforcement (5)** in the same way.

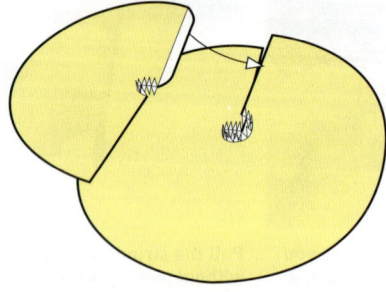

5 Turn both pieces right side up, and glue them together as shown.

6 Slip the Core through the hole in the center. Glue the triangular tabs to the core, so that the Wing fits right over the dotted line. The edges of the Wing should just touch the circles at each end of the dotted line.

62 Leonardo da Vinci's Flying Machines

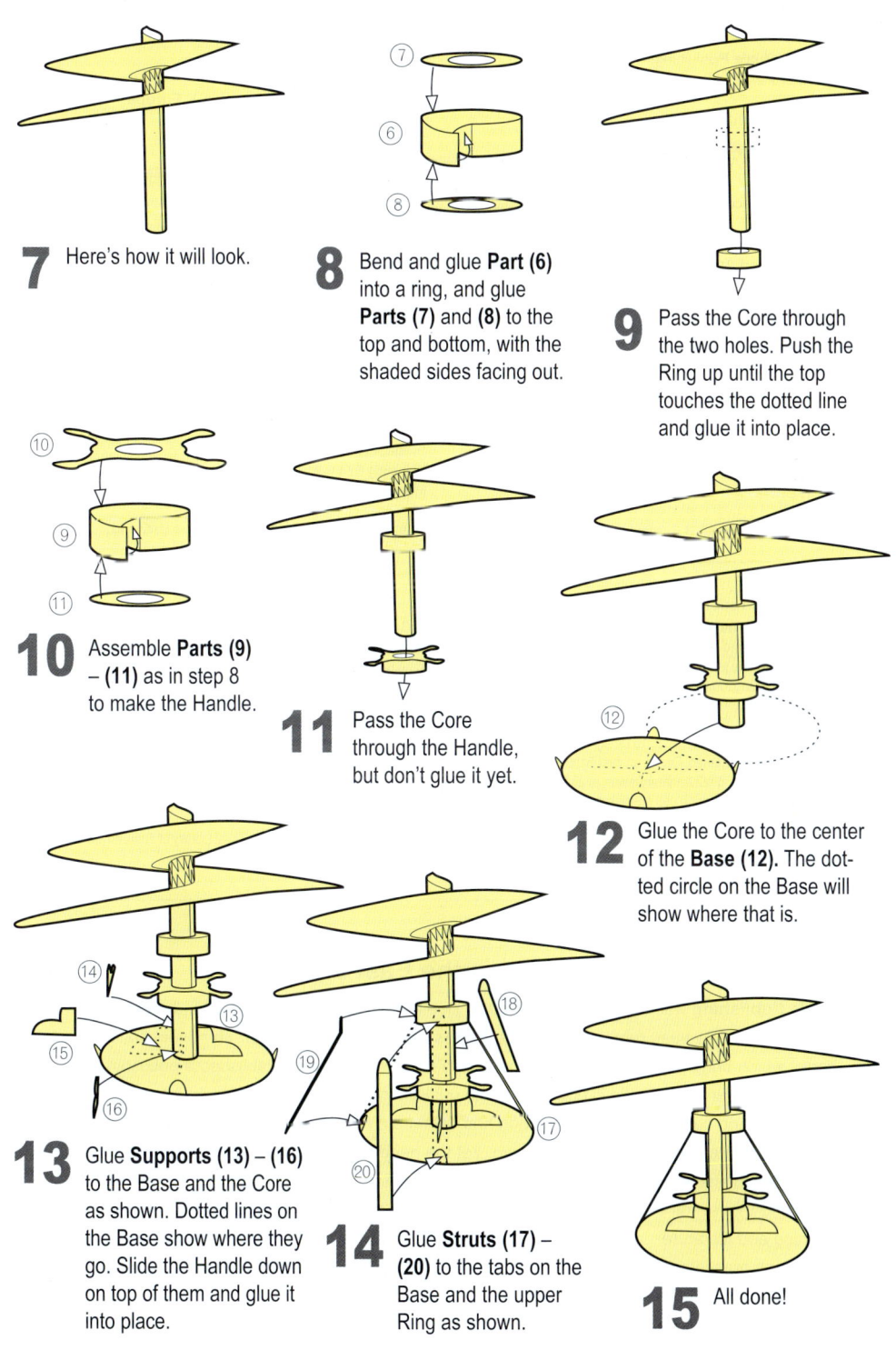

7 Here's how it will look.

8 Bend and glue **Part (6)** into a ring, and glue **Parts (7)** and **(8)** to the top and bottom, with the shaded sides facing out.

9 Pass the Core through the two holes. Push the Ring up until the top touches the dotted line and glue it into place.

10 Assemble **Parts (9) – (11)** as in step 8 to make the Handle.

11 Pass the Core through the Handle, but don't glue it yet.

12 Glue the Core to the center of the **Base (12)**. The dotted circle on the Base will show where that is.

13 Glue **Supports (13) – (16)** to the Base and the Core as shown. Dotted lines on the Base show where they go. Slide the Handle down on top of them and glue it into place.

14 Glue **Struts (17) – (20)** to the tabs on the Base and the upper Ring as shown.

15 All done!

The Helicopter

Published by Tuttle Publishing,
an imprint of Periplus Editions (HK) Ltd.

www.tuttlepublishing.com

Copyright © 2019 Andrew Dewar

Pop-out model decorations designed by Niño Carlo J. Suico

All rights reserved. No part of this publication may be reproduced or utilized in any form or by any means, electronic or mechanical, including photocopying, recording, or by any information storage and retrieval system, without prior written permission from the publisher.

ISBN 978-0-8048-5224-1

28 27 26 25 24
8 7 6 5 4 2403CM
Printed in China

Distributed by

North America, Latin America & Europe
Tuttle Publishing
364 Innovation Drive, North Clarendon,
VT 05759-9436, USA
Tel: (802) 773 8930 | Fax: (802) 773 6993
info@tuttlepublishing.com | www.tuttlepublishing.com

Japan
Tuttle Publishing
Yaekari Building 3F, 5-4-12 Osaki, Shinagawa-ku, Tokyo 141-0032, Japan
Tel: (81) 3 5437 0171 | Fax: (81) 3 5437 0755
sales@tuttle.co.jp | www.tuttle.co.jp

Asia Pacific
Berkeley Books Pte. Ltd.
3 Kallang Sector, #04-01
Singapore 349278
Tel: (65) 6741-2178 | Fax: (65) 6741-2179
inquiries@periplus.com.sg | www.tuttlepublishing.com

TUTTLE PUBLISHING® is a registered trademark of Tuttle Publishing, a division of Periplus Editions (HK) Ltd.

Photo & Illustration Credits

pp. 1–5 Andrew Dewar; p. 6 (left) Presumed self-portrait, (right) Helicopter / British Museum, London; p. 7 Design for a flying machine, Codex Atlanticus / Photo by Luc Viatour / https://Lucnix.be. Biblioteca Ambrosiana, Milan, Italy. Distributed under a CC BY-SA 1.0, 2.0, 2.5, 3.0 license; p. 8 (bottom left) Folio 6 recto, Codex on the Flight of Birds; p. 10 Hein Nouwens / Shutterstock.com; p. 12 Study of water / Royal Library, United Kingdom; p. 13 (right) Studies of water passing obstacles and falling / http://www.drawingsofleonardo.org, (left) Tavola 28 / Rare Book Division, The New York Public Library Digital Collections. 1828; p. 14 Folio 16 verso, Codex on the Flight of Birds; p. 15 Design for a flying machine, Codex Atlanticus / Photo by Luc Viatour / https://Lucnix.be. Biblioteca Ambrosiana, Milan, Italy. Distributed under a CC BY-SA 1.0, 2.0, 2.5, 3.0 license; p. 16 Design for a flying machine / http://www.drawingsofleonardo.org; p. 17 Flying machine / Institut de France; p. 18 Folio 17 verso, Codex on the Flight of Birds; p. 19 Illustration by Babin / Shutterstock.com; p. 20 Andrew Dewar; p. 21 Parachute / http://vinci.ru; p. 22 Andrew Dewar; p. 23 Folio 11 verso, Codex on the Flight of Birds; pp. 24–32 Andrew Dewar; p. 33 (top) Andrew Dewar, (bottom left and right) estt / iStockphoto.com; pp. 34–36 Andrew Dewar; p. 37 Kwirry / Shutterstock.com; pp. 38–63 Andrew Dewar.

Except where noted above on pages 6–23: All illustrations by Leonardo da Vinci, all photos courtesy of the Royal Library of Turin; all photos distributed under a CC0 license.

"Books to Span the East and West"

Tuttle Publishing was founded in 1832 in the small New England town of Rutland, Vermont [USA]. Our core values remain as strong today as they were then—to publish best-in-class books which bring people together one page at a time. In 1948, we established a publishing outpost in Japan—and Tuttle is now a leader in publishing English-language books about the arts, languages and cultures of Asia. The world has become a much smaller place today and Asia's economic and cultural influence has grown. Yet the need for meaningful dialogue and information about this diverse region has never been greater. Over the past seven decades, Tuttle has published thousands of books on subjects ranging from martial arts and paper crafts to language learning and literature—and our talented authors, illustrators, designers and photographers have won many prestigious awards. We welcome you to explore the wealth of information available on Asia at **www.tuttlepublishing.com**.